Remembering United States Naval Academy

James W. Cheevers

TRADE PAPER PRESS

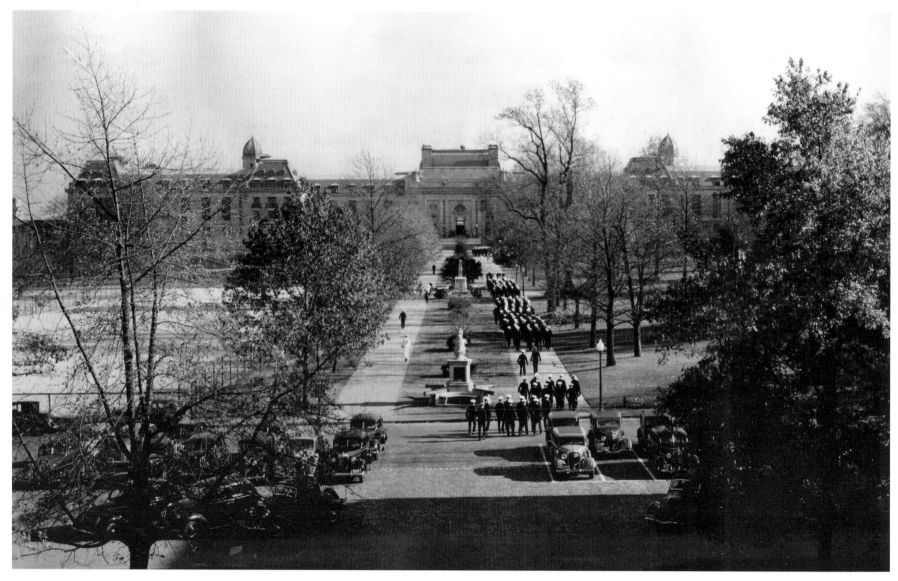

A main thoroughfare in the New Naval Academy, then and now, is a divided sidewalk named for the third Superintendent, Cornelius K. Stribling, connecting the dormitory complex, Bancroft Hall, and the academic buildings centered on Mahan Hall. For generations, units of midshipmen marched along this brick walk to and from nearly all their classes. In the median strip along the way are three important monuments: the figurehead of USS *Delaware* (also known as "Tecumseh"), the Mexican War Monument, and the Macedonian Monument.

Remembering

United States
Naval Academy

Turner Publishing Company
200 4th Avenue North • Suite 950
Nashville, Tennessee 37219
(615) 255-2665

Remembering United States Naval Academy

www.turnerpublishing.com

Library of Congress Control Number: 2010926207

ISBN: 978-1-59652-683-9

Printed in the United States of America

10 11 12 13 14 15 16—0 9 8 7 6 5 4 3 2 1

Contents

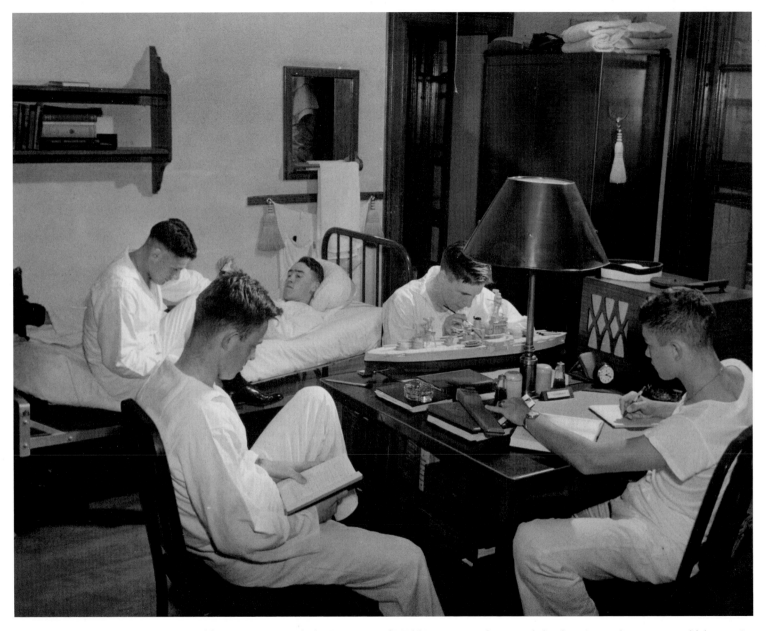

As World War II progressed, the Regiment of Midshipmen grew larger and the dormitory, classrooms, and laboratories became more crowded. At times, four lived in a room designed for two.

ACKNOWLEDGMENTS

No one deserves more credit for this volume than the photographers who used the equipment and their talents to take and to process the pictures. This work is dedicated to them. Like many photos of public institutions, which are copied over and over, not all the pictures found and used may be properly credited to the artist. It is known that a few are the work of two illustrious geniuses, Mathew B. Brady (1823-96) and Frances Benjamin Johnston (1864-1952). Some dating from the mid-1940s were credited to a Chief Jorgensen, who was clearly an active-duty sailor sent to the academy at the time by the Navy's Chief of Information to provide pictures to help celebrate the U.S. Naval Academy's 100th anniversary.

Of particularly valuable service to me over the past 40 years have been the professionals of the U.S. Naval Academy Photography Laboratory, who have captured and preserved, and continue to do so, a visual record of the school, its people, and its events. They are Jack Moore, David Eckard, Ken Mierzejewski, Wayne McCrea, Cliff Maxwell, Shannon O'Connor, and Gin Kai. They are among the unsung heroes who make it possible for us to remember and to study our past.

Turner Publishing has done a considerable amount of research for this book at two of the nation's premier storehouses of knowledge, the Library of Congress and the National Archives, whose employees again are often unrecognized for their outstanding abilities and the many hours they devote to helping fellow citizens.

A hardy thank you, too, to all the midshipmen, alumni, faculty, and all the employees of the U.S. Naval Academy, from the Superintendents to the housekeepers, who over the years have kept the questions on the school's history flowing. They have provided a fantastic learning experience, without which the information researched and recorded here would not have been uncovered. The mind is fallible and I appreciate receiving corrections to any unintended errors or misconceptions that may have crept in.

—*James W. Cheevers*
Annapolis, Maryland, 2008

PREFACE

The people, buildings, and grounds of the U.S. Naval Academy have changed so much during its existence we are fortunate that its history has coincided with that of photography. Cameras have provided an excellent record of the school's students, faculty, staff, classrooms, laboratories, infantry and artillery drills, parades, athletic contests, monuments, training ships, architecture, topography, and even its mascots and trees. Very little was left to the whims of artistic license. Indeed, the dearth of artistic renderings of the academy's personnel and architecture painted on canvas, drawn on paper, or etched for a graphic medium may stem from the fact that the academy's entire development has been captured through the lenses of cameras. There is a generous collection of photographs, tens of thousands of them, in the U.S. Naval Academy Archives and in other repositories such as the Library of Congress, the National Archives, and the Naval Historical Center Photographic Branch.

None of the original buildings of the Naval Academy have survived. The academy's infrastructure was completely razed and new construction undertaken between 1899 and 1908. Even some of the buildings from the early twentieth century have now disappeared in the name of progress. Contemporaneous photographs are the best means to recall and to study the appearance and workings of the old school. Through these pictures we can see what the academy was like in the student days of George Dewey, NA Class of 1858, and Alfred Thayer Mahan, NA Class of 1859; when the future naval leaders of World War I walked the yard in the 1880s; and when the Spanish-American War was fought in 1898. Incidentally, the first-known motion picture film shot in Maryland showed the arrival of Spanish prisoners of war at the Naval Academy on July 15, 1898, but that is a subject for another book. I hope that you enjoy this photographic journey through the past, from the earliest days of the academy to recent times.

The mission of the United States Naval Academy is to develop midshipmen morally, mentally, and physically and to imbue them with the highest ideals of duty, honor, and loyalty in order to provide graduates who are dedicated to a career of naval service and have potential for future development in mind and character to assume the highest responsibilities of command, citizenship, and government.

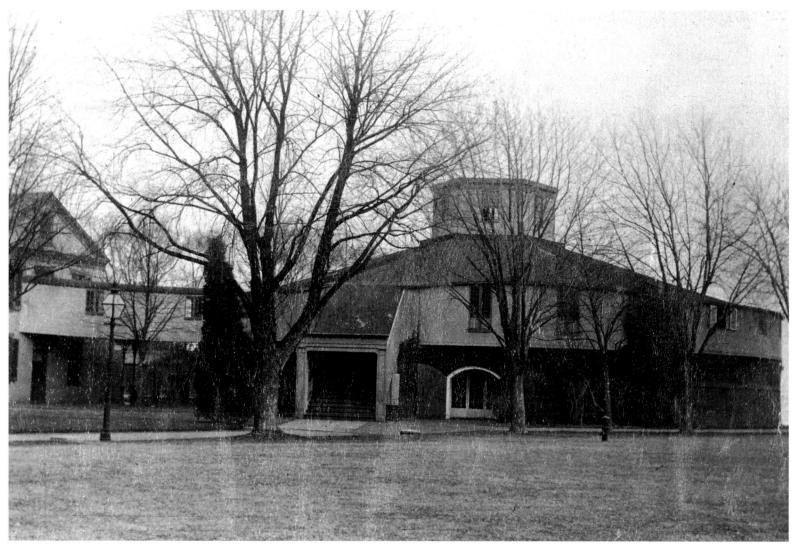

Fort Severn. Initially, the Naval School used the existing buildings of the fort. The circular battery mounting the guns was used for gunnery practice. It was later topped with walls and a roof to be the gymnasium of the school. Besides being used for fencing, gymnastics, and boxing, its large interior circular space became the site of many social functions such as the annual farewell ball given by the second or junior class to honor the first or graduating class.

From Fort Severn to Fort Adams

(1845–1865)

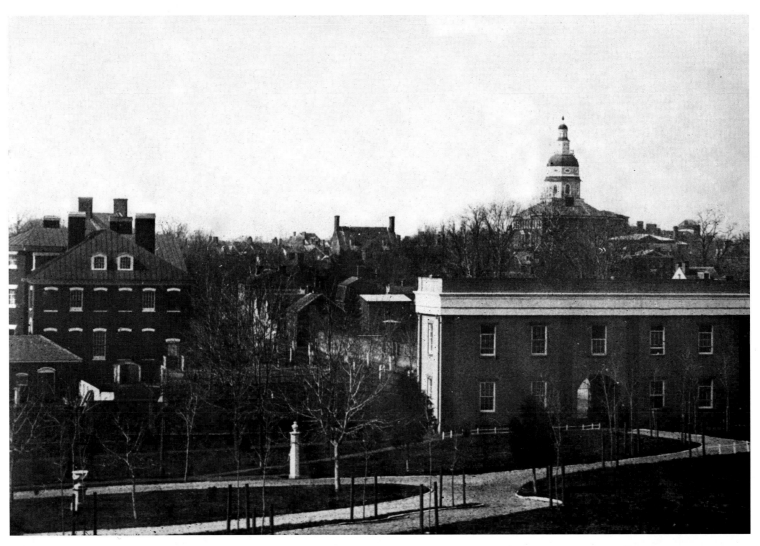

Gatehouse. Inherited from the War Department as the main entrance to Fort Severn, it continued to serve as the gate and offices of the watchmen hired to process residents and visitors as they entered and departed the school grounds. Left to right in the background are the Maryland governor's mansion; the former home (with chimneys on either end) of William Paca, one of the four Maryland signers of the Declaration of Independence; and the impressive eighteenth-century wooden dome of the Maryland State House, today the oldest state capitol in continuous use.

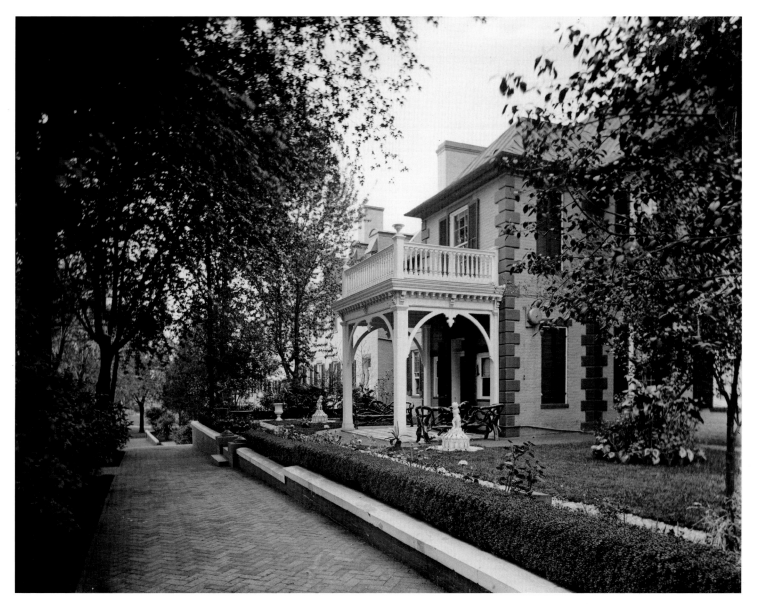

The Superintendent's House had been the residence of the commandant of the fort. Commander Franklin and Anne Catherine Lloyd Buchanan moved into the house in September 1845, and it continued to serve the first 12 superintendents of the Naval Academy. Adjacent to it, on what became Buchanan Row, was a series of attached homes where the first faculty and their families resided; and at the end a separate house, once the quartermaster's office of the fort, was converted to a home for the Navy chaplain.

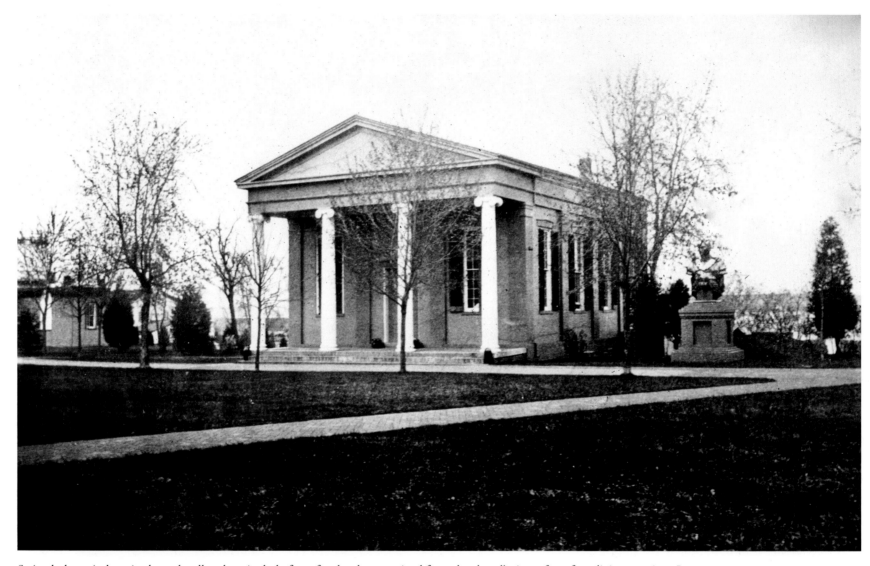

Stained-glass windows in the end wall and a raised platform for the altar remained from the chapel's time of use for religious services. In 1973, the first meeting of the U.S. Naval Institute was held in this room. It was occasionally used, too, for class hops or dances and for theatrical performances.

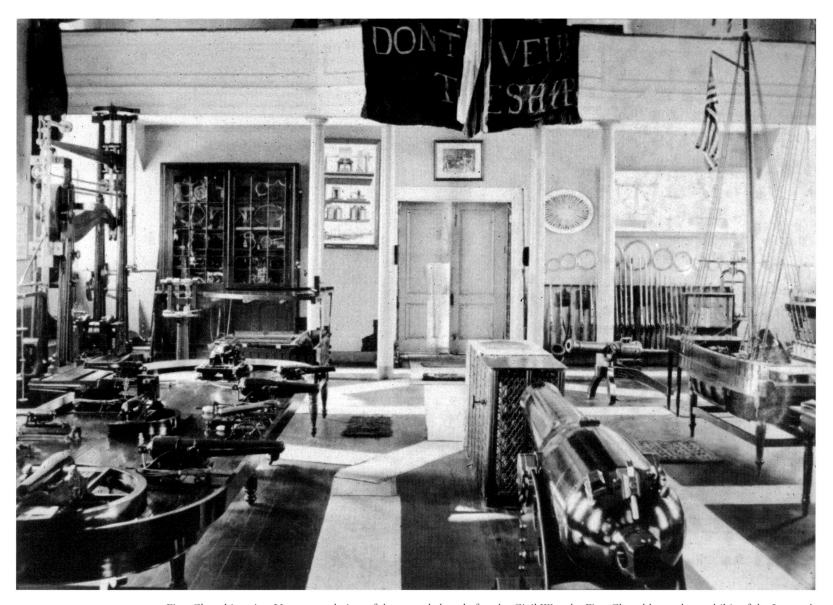

First Chapel interior. Upon completion of the second chapel after the Civil War, the First Chapel housed an exhibit of the Lyceum's historic flags, small arms, and ordnance. Commodore Oliver Hazard Perry's famous 1813 battle flag from Lake Erie emblazoned with the dying words of Captain James Lawrence, "Don't Give Up the Ship," can be seen hung from the former choir loft.

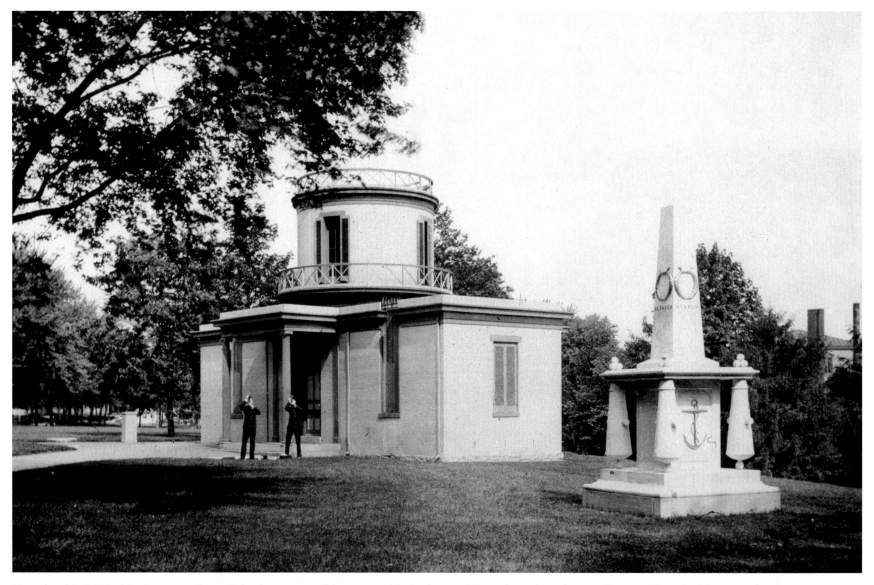

Completed in 1854, this observatory housed the department of Astronomy, Navigation, and Surveying, where the use of sextants for celestial navigation was taught. In the foreground is the Mexican War Monument, commissioned by the midshipmen to honor four fellow midshipmen who died in the war. When installed in 1848, as the first great monument at the school, it was known simply as the Midshipmen's Monument.

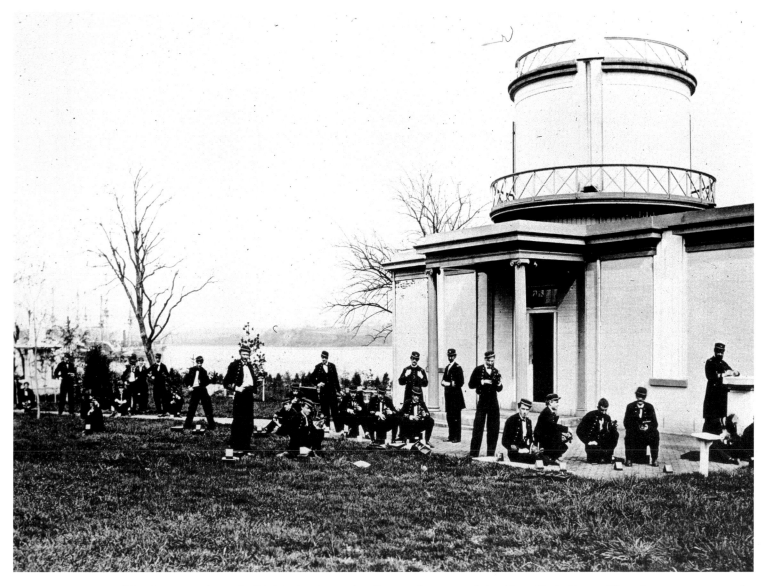

The observatory housed a 7.75-inch achromatic refractor telescope made by Alvan Clark, Boston. The telescope was among the finest optical instruments of the period. When the observatory closed in 1907, the telescope was sent to the U.S. Naval Observatory in Washington for safekeeping. On a field trip in 1986, the midshipmen astronomy club rediscovered the crate, marked "Naval Academy," and in 1991, the telescope was returned to the academy and mounted in a newer observatory made possible through the generosity of the Class of 1941.

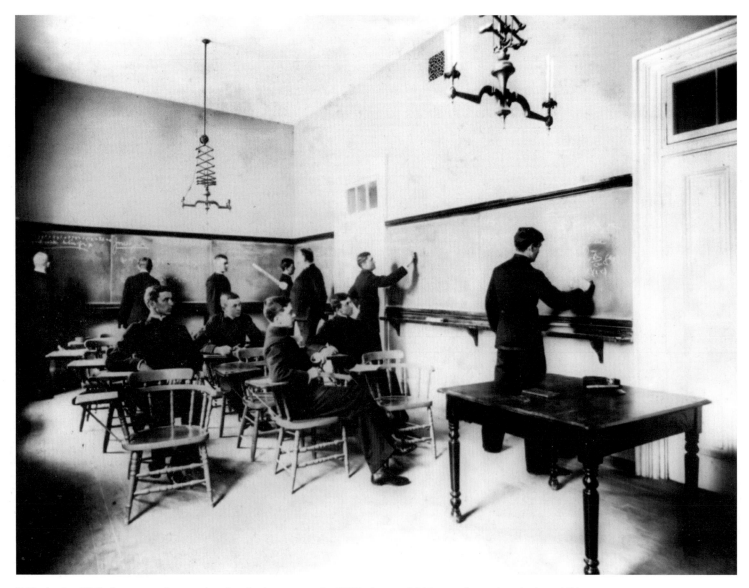

A Recitation Hall classroom picture taken late in the century, in 1895, shows midshipmen "manning the boards" in a mathematics class. Each student was graded each day by the professor; in the early years, at the end of each month, the grades were reported to the Secretary of the Navy in Washington. This photograph was made by Frances Benjamin Johnston (1864-1952), a photojournalism pioneer.

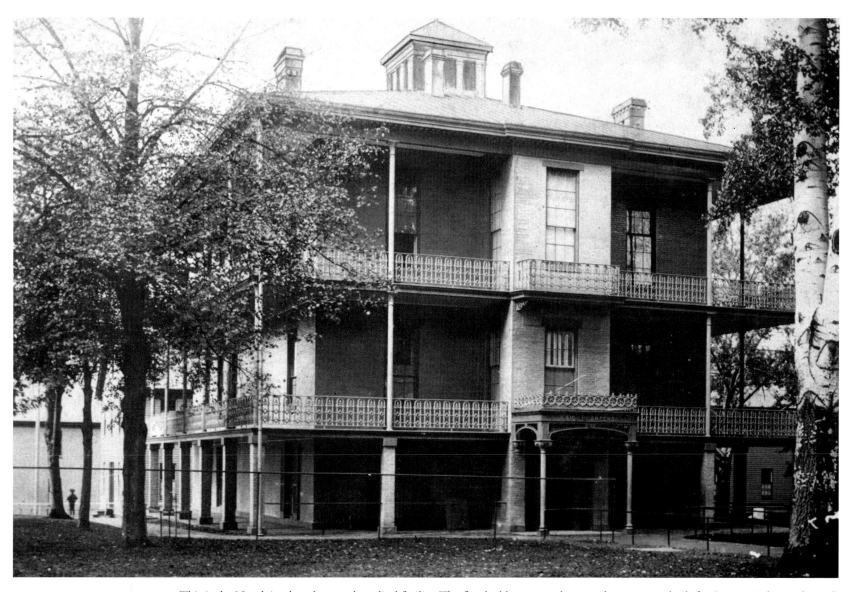

This is the Naval Academy's second medical facility. The first had been a modest wooden structure built for Surgeon John Lockwood, the first doctor assigned to the school, near the historic mulberry tree on Spa Creek. The second hospital, built in 1857, stood where the Officers and Faculty Club is today. The wraparound porches on each level speak to the use of plenty of fresh air to help restore the health of sick midshipmen.

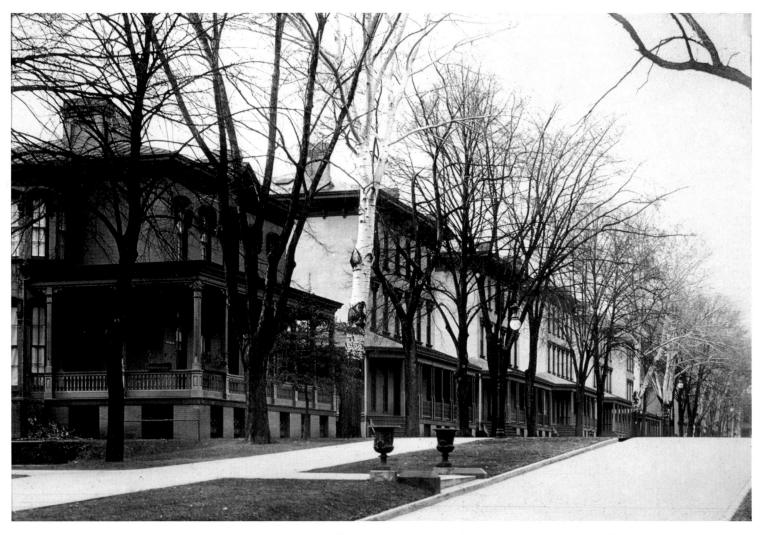

Completed in 1859, during the administration of Captain George Blake, the single-family house in the foreground was the residence of the Commandant of Midshipmen, the equivalent of a dean of students. The commandant, usually the second-ranking officer on the staff, is in charge of the day-to-day life and the professional development of the students.

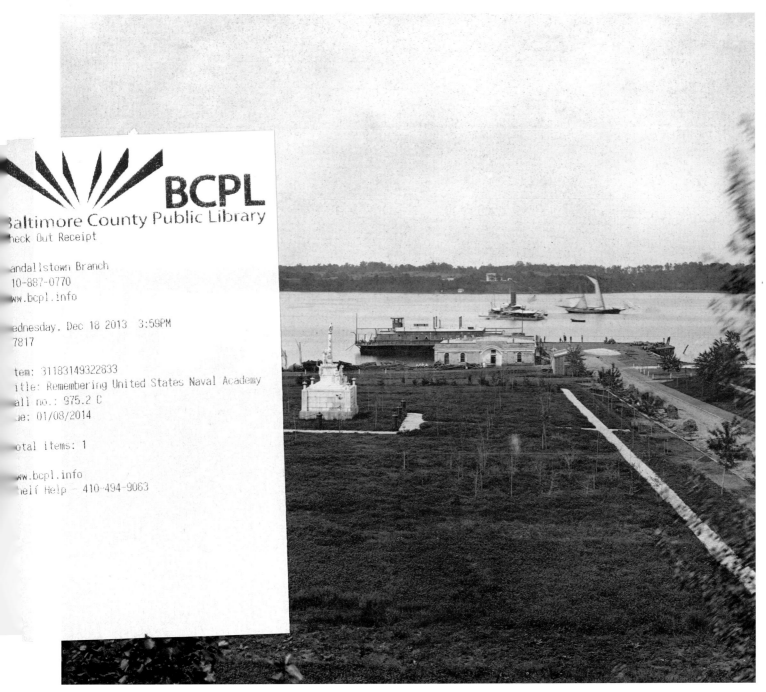

This photograph is credited to Mathew Brady. The scene includes the oldest United States Navy monument. It was carved in Italy and commemorates six officers killed in the Barbary War against Tripoli in 1804. It was originally erected in the Washington Navy Yard in 1807, and known simply as the U.S. Naval Monument. In 1835, it was moved to the west terrace of the U.S. Capitol where it was surrounded by a moat of water. In November 1860, it was moved to the site in the picture at the Naval Academy. The wharf at the end of Maryland Avenue on the Severn River accommodated a ferryboat named *Phlox,* which carried passengers across to the north shore of the river and to other landings in the area.

The U.S. Naval Monument includes one of the few rostral columns, devised by the Romans in 250 B.C. as a means to honor naval heroes, in America. The column has ships sailing through it, bow on one side, stern on the other. The monument features allegorical figures: Commerce, which the Navy was defending, America in the form of a female Native American with two children, and History making a record of the events.

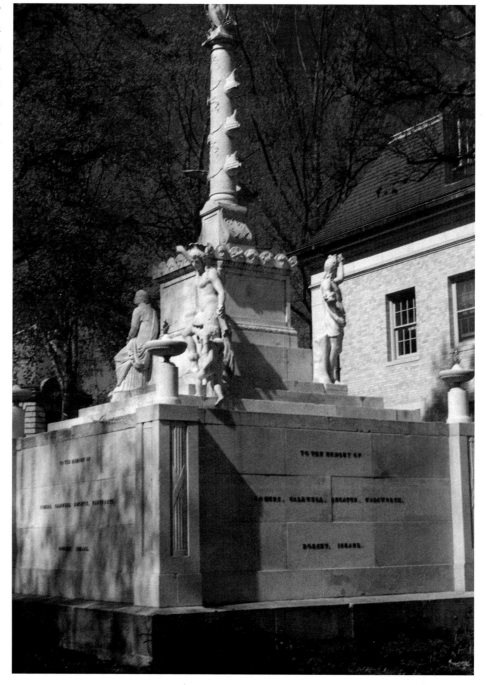

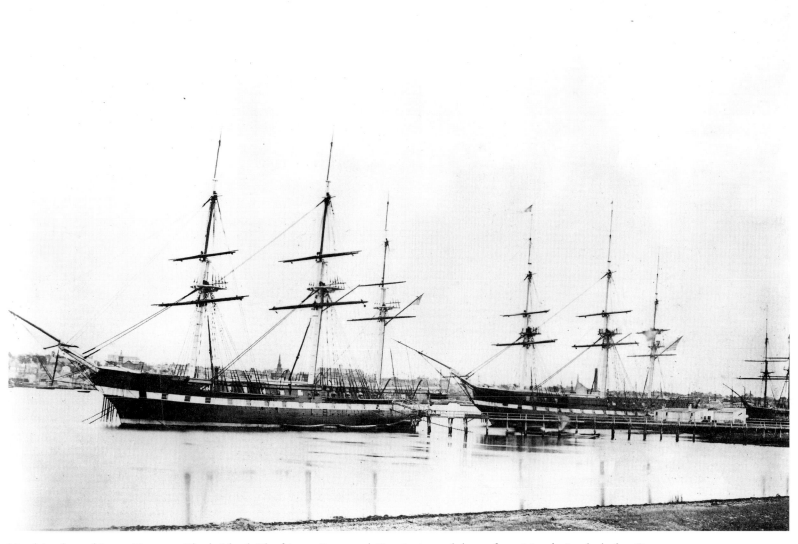

Naval Academy ships, at Newport, Rhode Island. The frigates *Santee* and *Constitution* and sloop of war *Macedonian* docked at Goat Island during the academic year and played an important role in helping to house the students and in providing additional classroom space. During the summer they were used for midshipmen cruises and practical exercises in seamanship and gunnery.

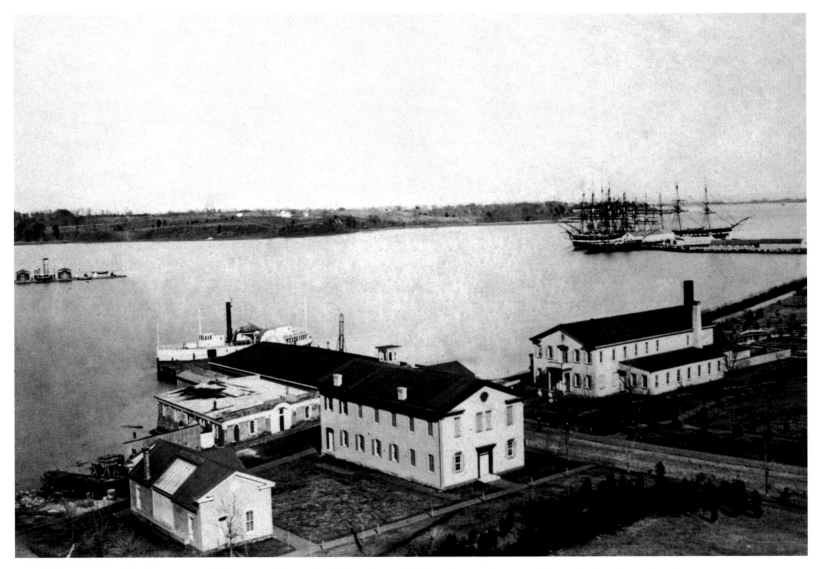

From left to right are the departments of Chemistry, Natural and Experimental Philosophy or science, and Steam Engineering. Chemistry was housed in a separate building, perhaps in case a student experiment with explosives went awry. Also housed in the chemistry building was a daguerrean gallery, the first photography lab at the school. Physics, optics, and later electricity and metallurgy were among the subjects studied in Natural Philosophy. A mansard roof with skylights and second story were later added to the Steam Engineering building and topographic and mechanical drawing taught on the top deck.

THE POST–CIVIL WAR PERIOD

(1866–1894)

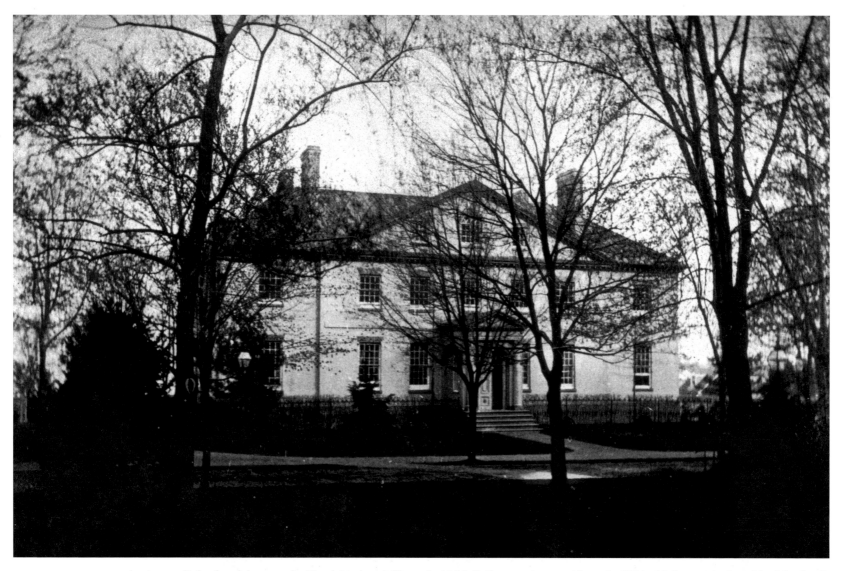

An Annapolis landmark became the Naval Academy's library in 1866. Built as a private residence in 1750, this house was leased by Maryland's colonial governor Horatio Sharpe and purchased by his successor, Robert Eden. After Governor Eden left the house in June 1776, the last colonial governor to abandon his station during the Revolution, it was confiscated by the new state of Maryland and became the official residence of thirty-two state governors. It was razed in 1899 to make room for a new armory. As the academy library, it had also held the office of the Superintendent and his immediate staff.

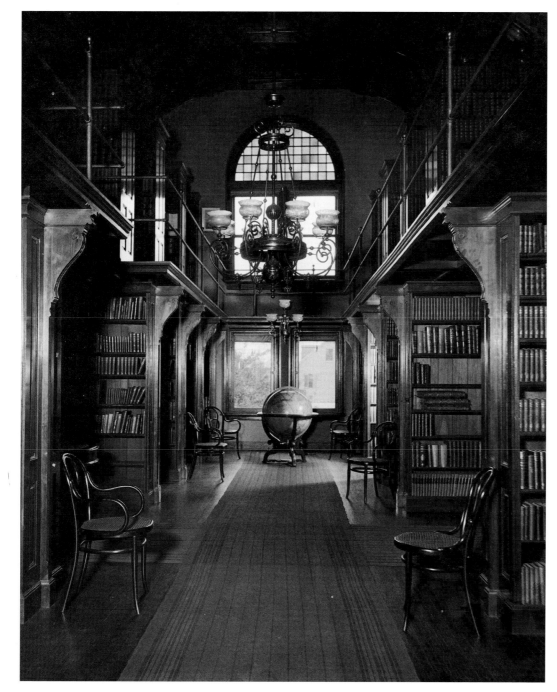

The large terrestrial Franklin globe in the distance was made by the Merrian Moore Company of Troy, New York, and purchased for the new library. It shows Alaska as Russian territory, so it was made before Seward's purchase of that territory in 1867. The globe was continually exhibited in the academy's main library until 1973, when it was moved to the museum for preservation. Expert globe conservators were found, it was restored, and it can be seen in today's Nimitz Library.

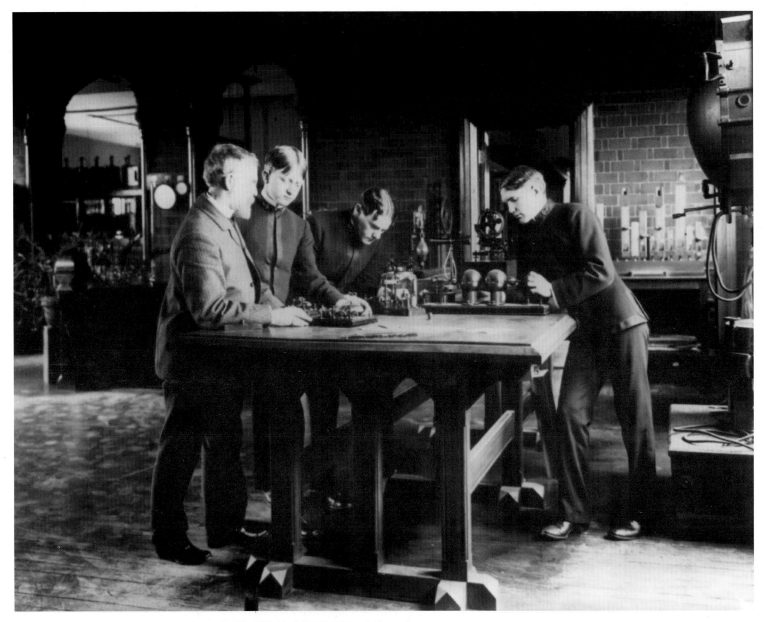

Inside the post–Civil War science building, a civilian professor and three midshipmen are studying wireless telegraphy in the late nineteenth century. Photograph by Frances B. Johnston.

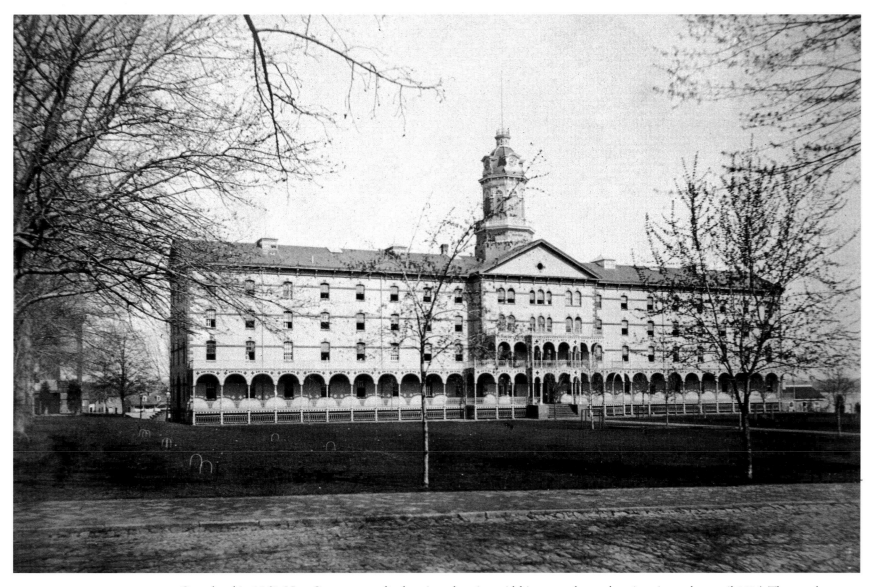

Completed in 1869, New Quarters was the dormitory housing midshipmen cadets and engineering cadets until 1904. The cupola on top held the first illuminated clock in Annapolis, with faces in four directions. On, and below, the long front porch and on the central facade were wrought-iron balustrades and decorative features. Some of this Baltimore-made wrought iron from New Quarters can still be found as fences around homes in downtown Annapolis, obviously rescued when the building was razed in 1905.

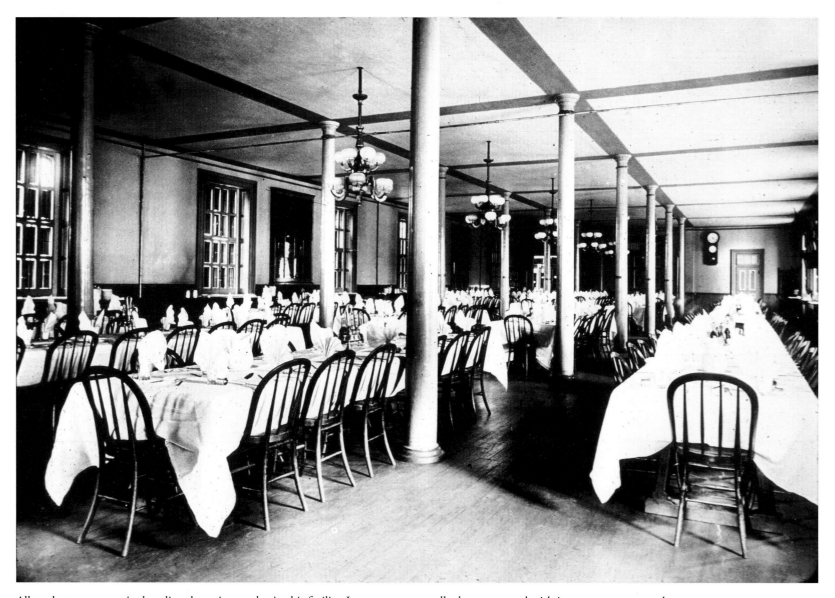

All students were required to dine three times a day in this facility. It appears very small when compared with its current successor, but classes after the Civil War were much smaller in number because of downsizing of the Navy. A wall clock at the far end of the room kept everyone on their tight schedule.

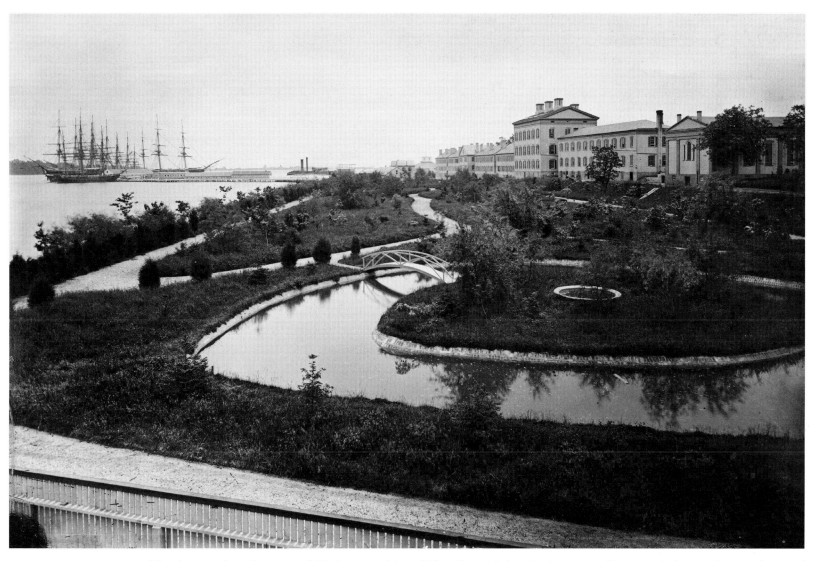

The photographer who captured this image, and it could have been Mathew Brady, was standing in a window on the second story of the Steam Engineering building looking south. After the Civil War the grounds were re-landscaped with roads and paths tastefully laid out and trees, shrubs, and flowers planted. Along the rise at upper-right is the backside, or river side, of Stribling Row built between 1846 and 1854, and including the antebellum chapel, mess hall-lyceum, and now the Seamanship Department, Recitation Hall, and the old dormitories. In the distance are the gas works and the wharf.

The red-brick Victorian gothic chapel with its imposing steeple once stood where the Superintendent's house is today. Dedicated in 1869, it was used for mandatory Sunday religious services until 1904 when it was razed for the construction of the New Naval Academy. The chapel was also used for graduation ceremonies. Late in its existence, it sheltered a school for Navy juniors, the children of officers and faculty working at the academy. The school was a predecessor to the present Naval Academy Primary School.

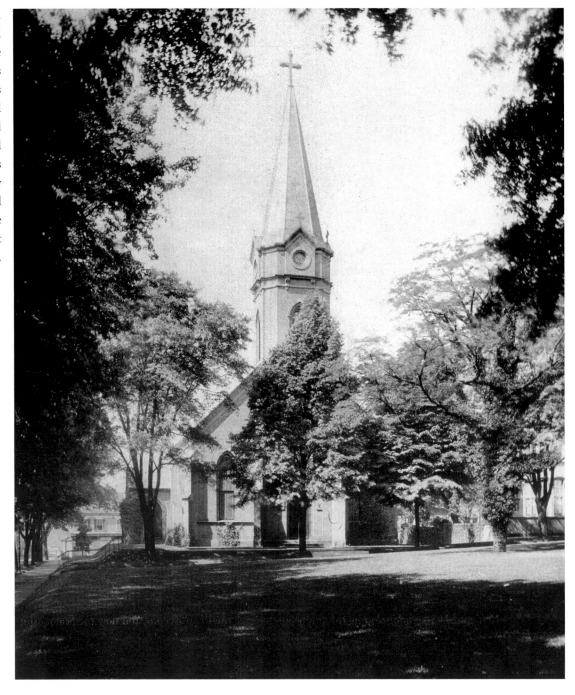

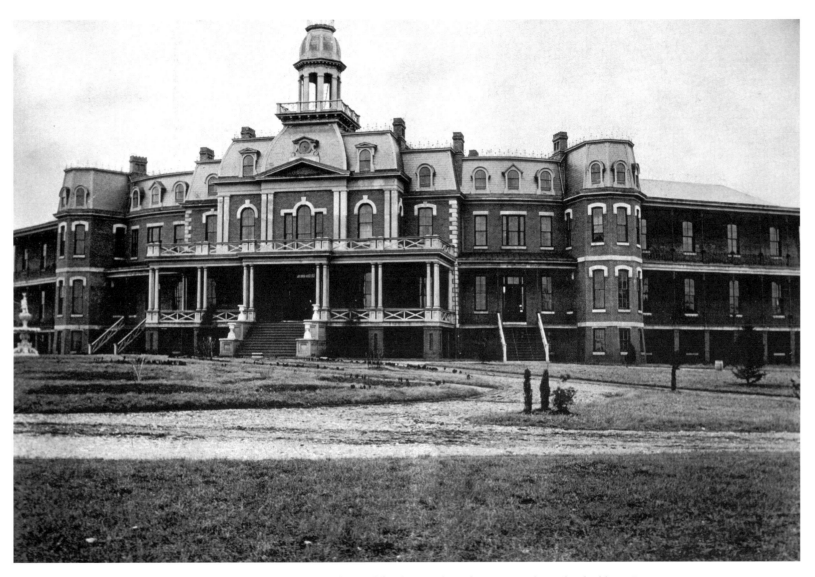

It looks like a grand Victorian hotel, but it was built to be a new hospital for the Naval Academy. It stood on what had been Prospect Hill farm, land purchased by the government in 1869. The site is currently occupied by a large light-green water tower. Planned during the Superintendency of Vice Admiral David Dixon Porter, it was too expensive to man and to maintain as the Navy fell on hard times after the Civil War, and it was used only briefly for its intended purpose. It was closed, boarded up, and sat abandoned for nearly 30 years before being razed. It came to be known locally as "Porter's Folly."

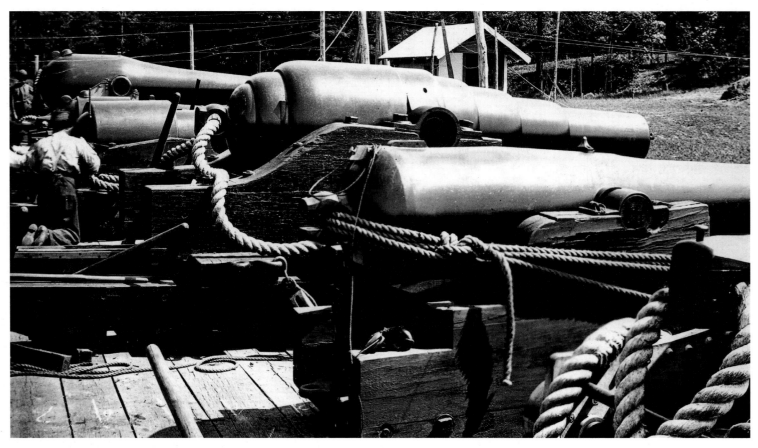

Because of the U.S. Naval Academy, the Navy has located a number of other activities in the vicinity over the years. Its ordnance grounds was the first. In 1873, the government purchased 83 acres on the north side of the Severn River across from the academy and established the Naval Ordnance Proving Ground, a test range for firing large guns southward down the Chesapeake Bay. Public complaints of noise and window-rattling forced its relocation to Indianhead, Maryland, on the Potomac River in 1892. In 1903, the Navy's Engineering Experiment Station was established across the Severn River. Among its most noted employees was Robert H. Goddard, who worked on developing rocket motors and jet-assisted takeoff for naval aircraft. The Engineering Station eventually became part of the David Taylor Naval Research and Development Center. The Annapolis lab was eliminated in the base closings of 2000. In 1910, the government purchased an additional 290 acres on Greenbury Point. Here in 1911, the Naval Academy golf course was first laid out. The U.S. Naval Academy Dairy Farm was located here briefly. In late 1911, the first Naval Air Station was built on Greenbury Point, consisting of a runway and an aerodrome shed for aircraft. Wright Brother and Curtis aeroplanes established many firsts from this location before the activity was moved to Pensacola, Florida, in early 1914. In 1918, the Navy's High Power Radio Station was founded on the same site. Its impressive towers transmitted high-powered, low-frequency communications to all ships and naval activities around the world before satellites took over this role. Other commands at times, in direct support of the school, have been the Navy Post Graduation School, which moved to Monterey, California, in 1951; the Naval Station, Annapolis; and the U.S. Naval Academy Hospital, which closed in 1974.

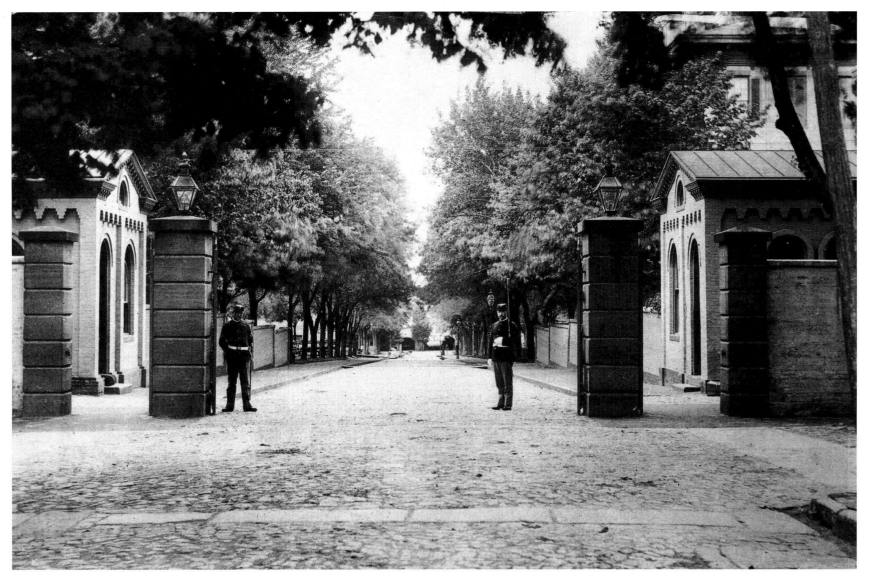

As the Naval Academy expanded its land holdings, a series of gates were added along the wall separating it from the city of Annapolis. In 1876, two gate houses were built at the Maryland Avenue entrance. Today these gate houses are the oldest buildings in the yard, the only nineteenth-century buildings remaining. Throughout the history of the school, the gates have been tended and guarded at different times by civilian watchmen, U.S. Marines, Department of Defense police, and sailors.

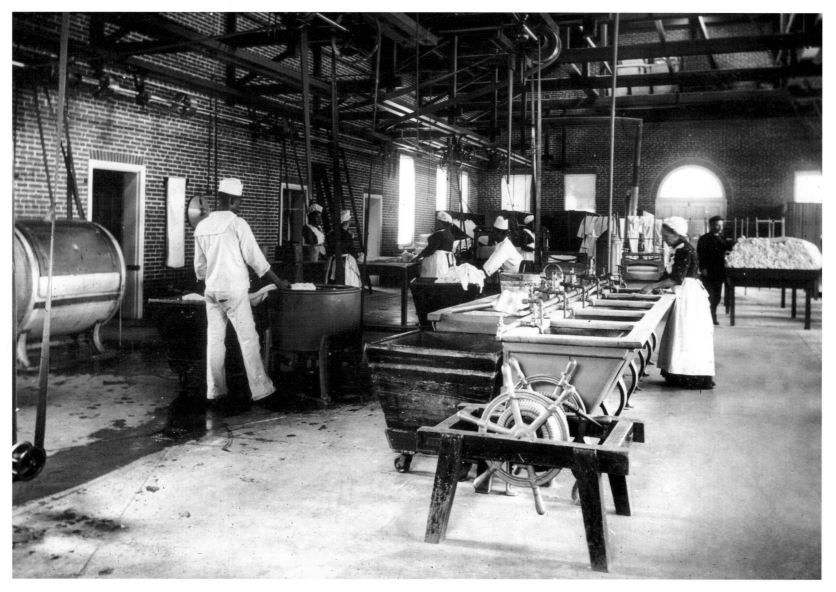

With hundreds in the 1880s, and today about 4,400, young and eager employees, the Naval Academy laundry has always been a large and vital operation. Generations of Annapolitans have proudly worked in the laundry, mess hall, and in caring for the buildings and grounds, making the lives and education of future naval leaders as pleasant and efficient as possible.

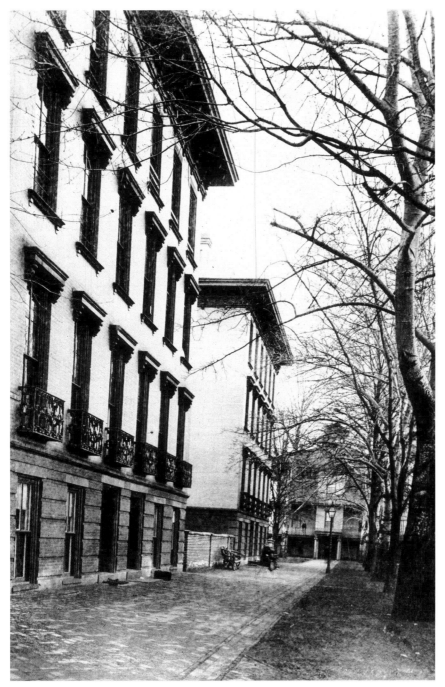

Goldsborough Row. Built during the superintendency of then Commander Louis M. Goldsborough, 1853-57, these two multi-family houses quartered staff and faculty for nearly 50 years. Located adjacent the Maryland Avenue gate, these houses once featured wrought-iron window guards today found on an existing apartment house outside the gate.

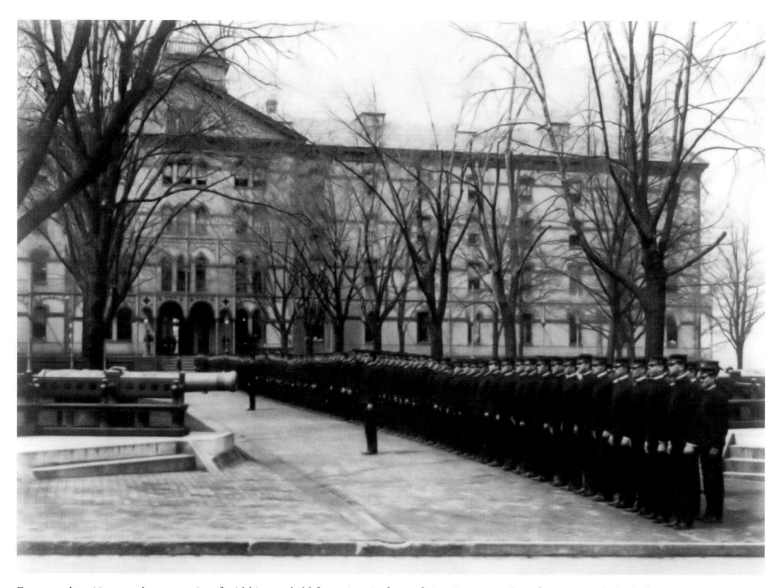

For more than 30 years, the companies of midshipmen held formations in front of New Quarters at least five times each day before meals and before marching to morning and afternoon classes. On either side of the formation are the First and Second Class Benches. This is yet another image by noted photographer Frances Benjamin Johnston, whose work appears in several places in this volume.

Interloping civilian visitors often failed to respect the tradition of who was qualified to sit on these reserved benches. Then again the young male midshipmen did not mind having such beautiful guests sit on their bench. The class benches remained in their original location long after New Quarters was razed. They were moved in 1938 when it was decided to convert the sidewalk they guarded into Decatur Road. Today the benches are found along Stribling Walk near Bancroft Hall.

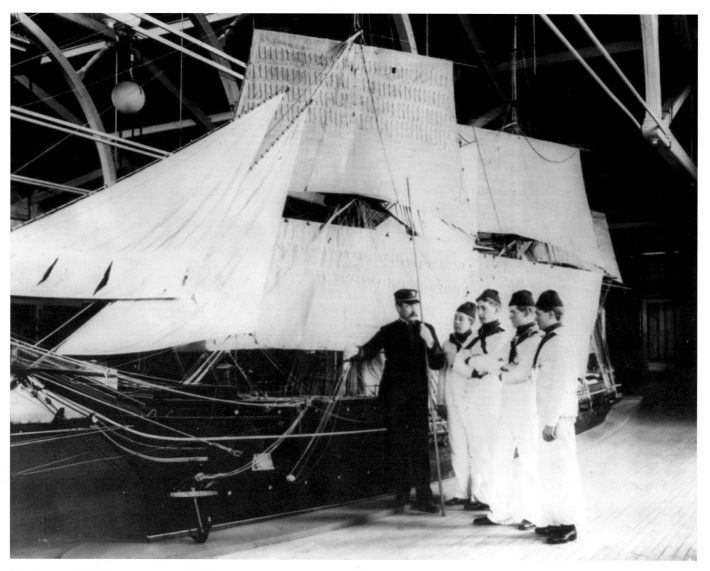

The large model of USS *Antietam,* a late Civil War screw sloop, was built for the Navy section in the Centennial Exposition held in Philadelphia in 1876. Afterward it was sent to the Naval Academy to help midshipmen in "learning the ropes." It was exhibited in the well of the old Seamanship Building and then moved to the seaward end of Macdonough Hall, the original site of the Department of Seamanship in the new academy. In 1976, the model was lent to the Smithsonian Institution for a re-creation of the 1876 Centennial exhibit in Washington as part of the celebration of the Bicentennial. Upon its return, this largest ship model at the school was mounted at the seaward end of Dahlgren Hall.

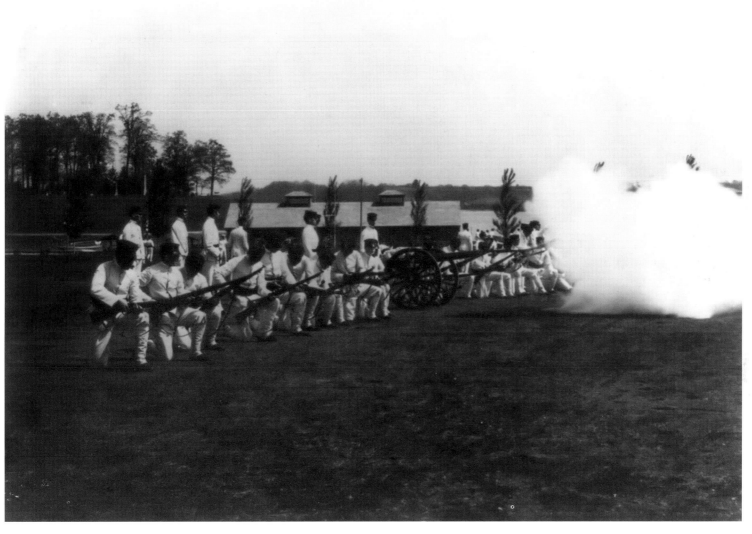

In the late nineteenth century, exercises with rifles and light artillery pieces, such as Dahlgren boat howitzers on wheeled carriages, were held along Dorsey Creek. The guns were fired across the water into the embankment of the cemetery on the other side.

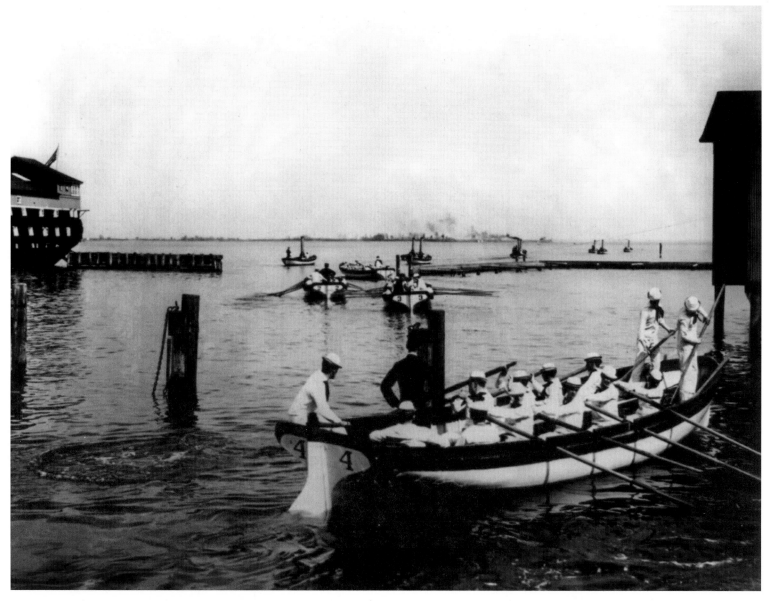

Plebes in their summer work whites and dixie cup hats are receiving instruction in properly loading, powering, and maneuvering cutters. At upper-left is a part of the stern of the roofed-over frigate *Santee*, which served as the academy's station ship until 1912.

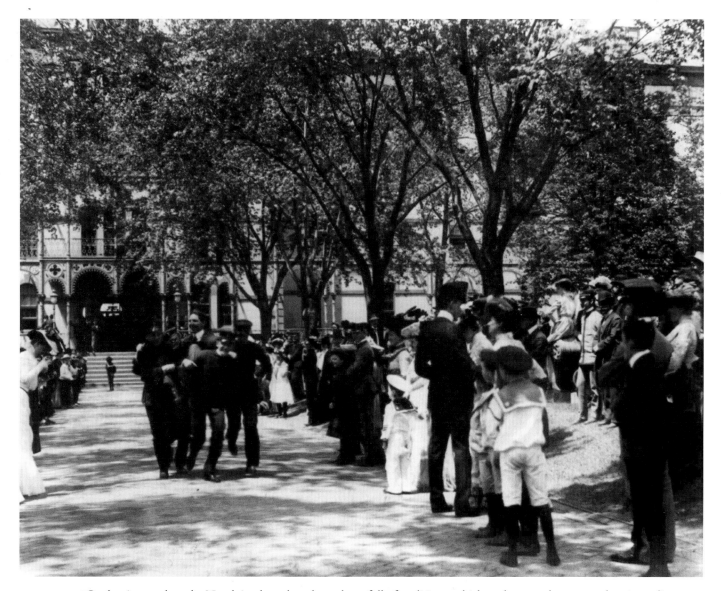

Graduation week at the Naval Academy has always been full of traditions, which evolve over the years and at times disappear. Here in front of New Quarters, spectators are observing what was known as "class rush," a custom abandoned after the move of the dormitory to Bancroft Hall. In class rush, all the midshipmen returned to New Quarters following the graduation ceremony. The underclassmen would then carry the new graduates out of the dormitory as they departed it for the last time.

Cast in 1456, this temple bell had been a diplomatic gift presented to Commodore Matthew C. Perry by the Regent of Lew Chew, now Okinawa, during his famous expedition to Japan in 1854, in which he signed the first western treaty with that nation. His widow presented the bell to the Naval Academy during June Week 1859. In 1900, the captain of the football team rang the winning score on the bell when Navy defeated Army, and a new custom was born. The tradition was later extended to other athletic teams that defeat Army. By doing so, teams earn the right to wear a large, gold letter "N" with star on their sweaters and jackets.

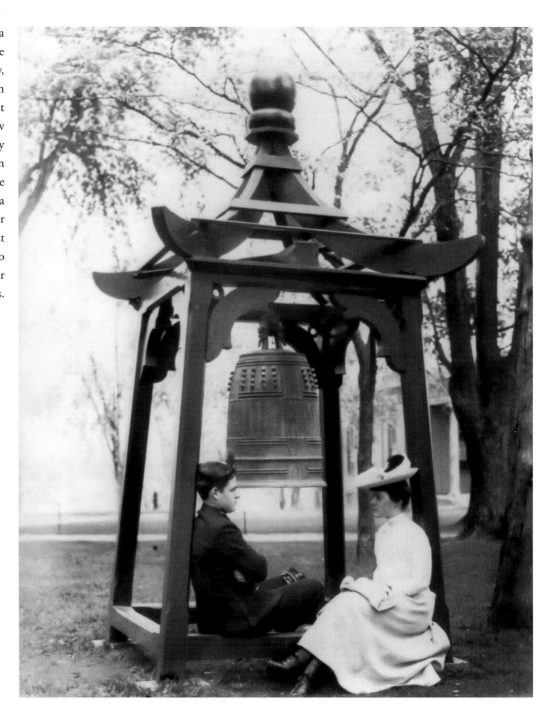

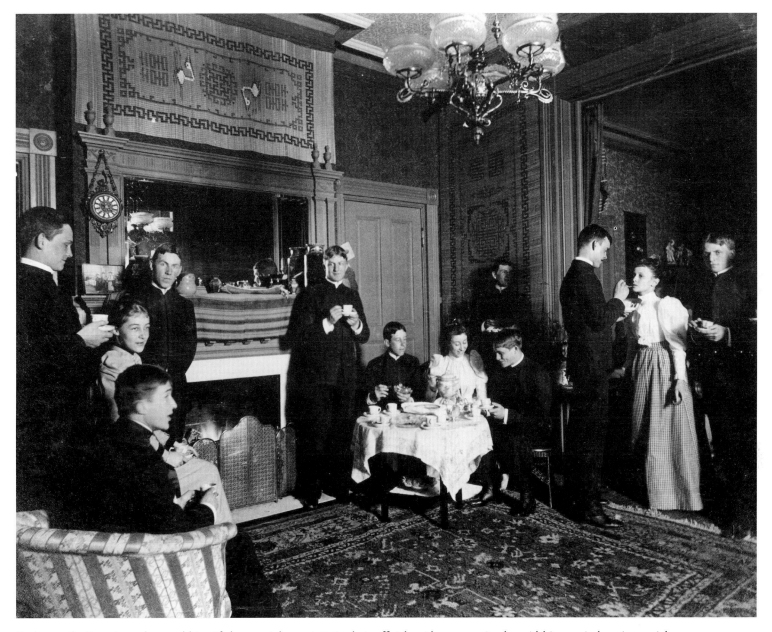

Each year the Superintendent and his wife host social occasions in their official residence to assist the midshipmen in learning social skills and manners so important to a successful career as an officer. Here the class of 1894 is partaking of tea in what was the second Superintendent's quarters, a large Queen Anne–style Victorian house used from 1886 until 1901.

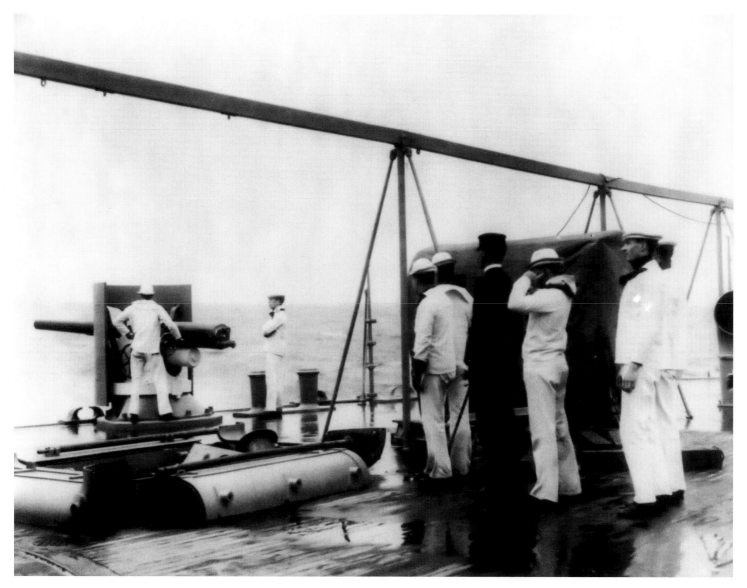

In the history of the Naval Academy, training with large guns began in the battery of Fort Severn, then moved to a battery of naval ordnance set up by Lieutenant John A. Dahlgren along the seawall, and then to Fort Adams near Newport. After the Civil War, the government purchased land across the Severn River and established an ordnance testing facility. When complaints of its shooting rattled too many windows in nearby homes, monitor-class vessels were assigned to take students out into the Chesapeake Bay for the firing of big guns.

THE NEW NAVAL ACADEMY: A GOLDEN AGE
FOR ANNAPOLIS

(1895–1947)

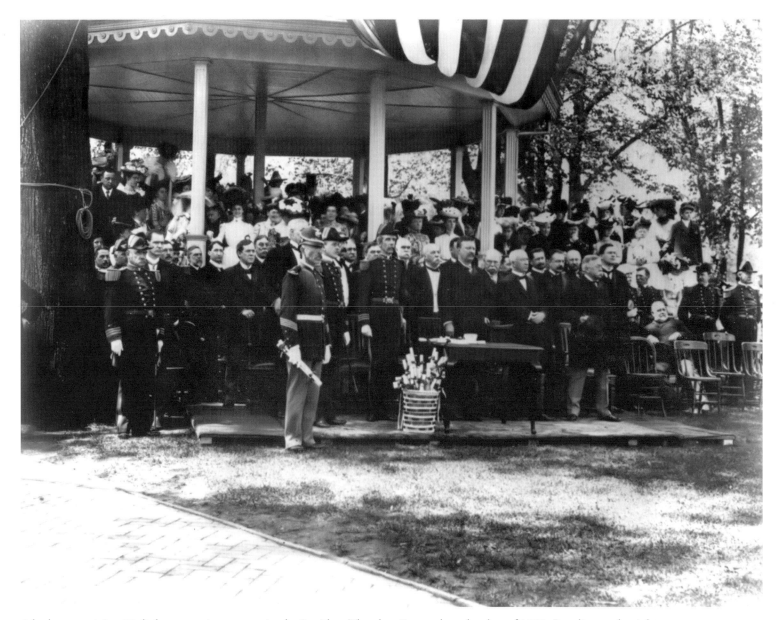

A basket containing 59 diplomas awaits presentation by President Theodore Roosevelt to the class of 1902. Standing to the right of the president in full dress uniform is Commander Richard Wainwright, the Superintendent, whose son, Midshipman Richard Wainwright, Jr., is among the graduates.

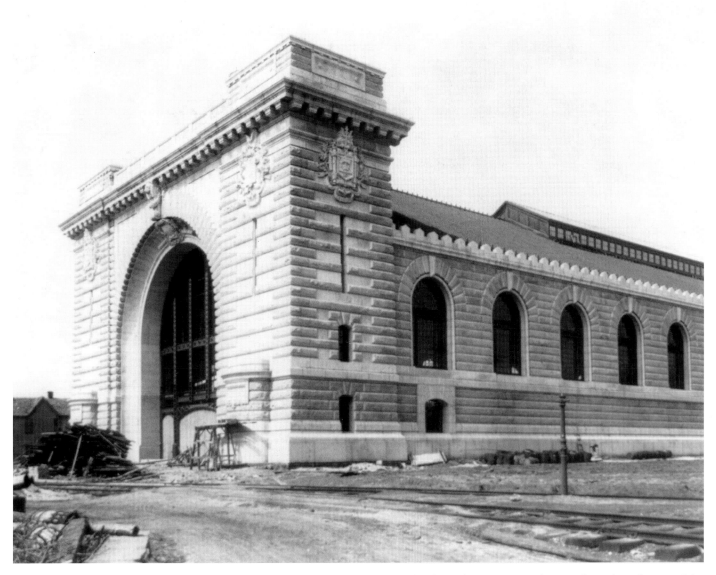

The first of the new Naval Academy buildings begun and completed was the armory. Its design reflects the influence of the Paris Exposition of 1889 on architect Ernest Flagg, shown in its massive stone masonry and large facades, at either end, of glass and iron. Begun in March 1899, it was first used for the early graduation of the class of 1903, on February 2, 1903, to meet the demand for junior officers in the new battleship Navy. Later it was named for Rear Admiral John A. Dahlgren, an important inventor of naval guns.

The grand new chapel was the last of the larger buildings to be completed. It was dedicated in a special service on May 24, 1908, to which the ministers of area churches were invited. It was originally designed and built in the shape of a Greek cross, with equal transepts, and sat 1,200 people. The copper dome was decorated in naval and military emblems cast in terra cotta, but they did not weather well and were removed in 1928.

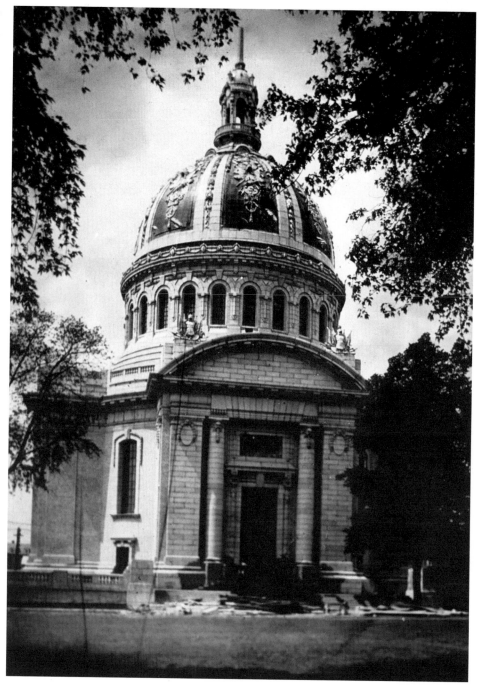

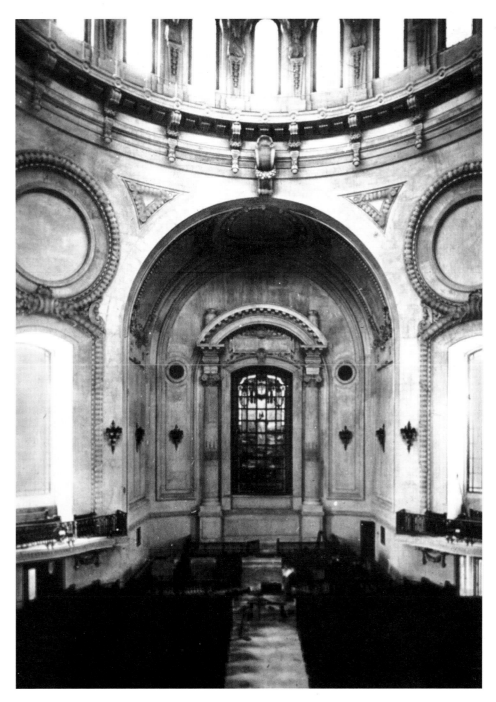

A nave was added to the chapel in 1940 by architect Paul Cret (1876-1945), doubling the seating capacity to 2,400. The exposed organ pipes on either side of the transept forming the apse are part of one of the largest pipe organs in the world.

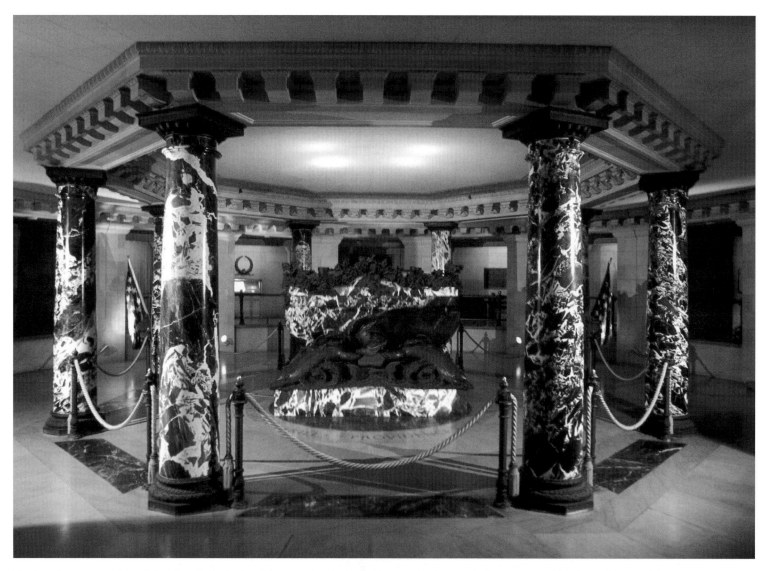

During the construction of the chapel, the body of Commodore John Paul Jones (1747-1792), the great naval leader and hero of the War for Independence, was rediscovered in Paris. With elaborate ceremony his casket was brought to Annapolis. Flagg designed a crypt, which remained incomplete for lack of funding. Seven years later additional money was appropriated and architect Whitney Warren (1864-1943) completed the work. The black-and-white marble sarcophagus is supported by bronze dolphins and decorated on top with bronze seaweed. In niches in the surrounding walls are exhibited swords, medals, documents, and other items associated with Jones's brief but exciting life.

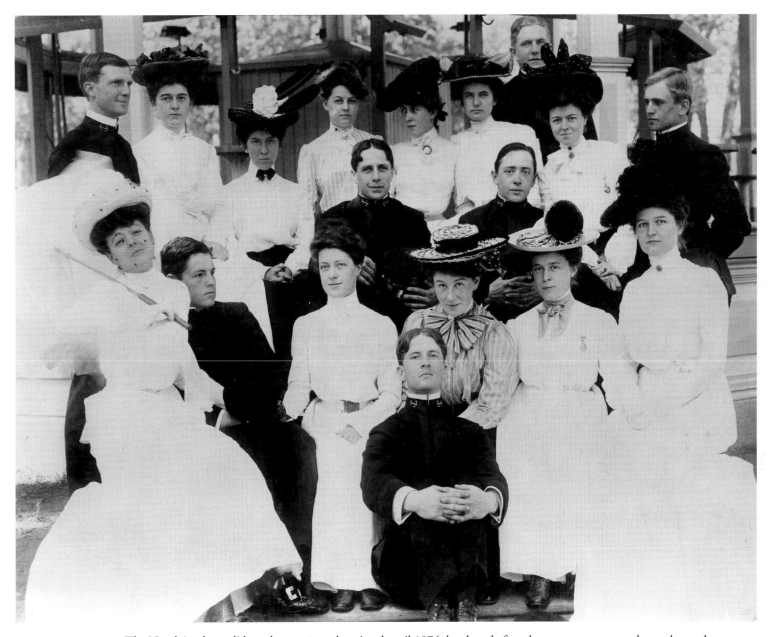

The Naval Academy did not become co-educational until 1976, but long before there were women students, the academy was a popular destination among young women, for social functions such as class hops, farewell balls, theatrical performances, and even athletic contests and dress parades.

Architect Flagg's academic complex was centered on the school's new library building named for Alfred Thayer Mahan, NA 1859, a noted naval historian and strategist. The hall also contained an auditorium. Although the midshipmen had produced and performed in theatrical plays since at least 1847, with the completion of this facility, they organized the Masqueraders, which has ever since presented a drama in the fall and a musical in the "dark ages" of February. The temporary light-bulb sign on the clock tower was made by the "juice gang," the electricians who also light the stage. It tells one and all that the Masqueraders are performing.

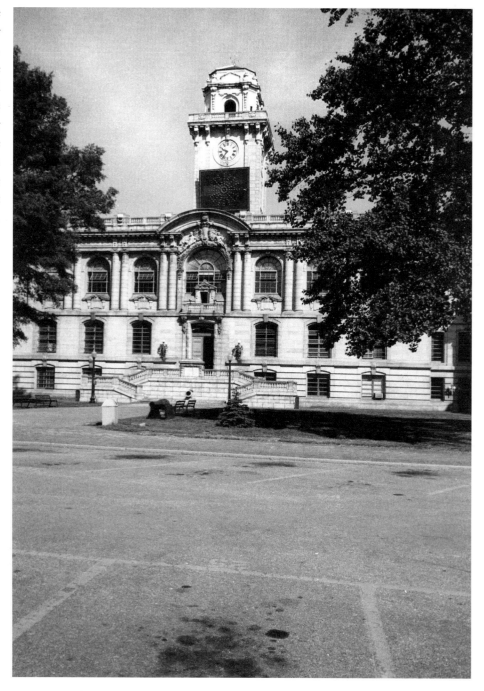

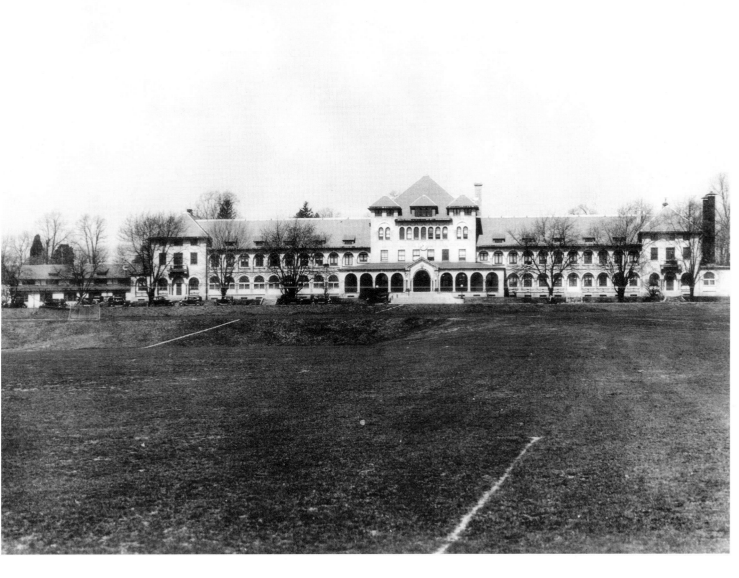

Halligan Hall was built in 1903 as the new Marine barracks. Henry Ives Cobb (1859–1931), famous for many late-nineteenth-century buildings in Chicago, was the architect. Before World War I, the academy's Post Graduate Department taught courses here; after the war, it became exclusively the Navy's Post Graduate School. After 1934, the building was named for Rear Admiral John Halligan, a founder of the post graduate program. The PG School moved to Monterey, California, in 1951. Today Halligan Hall houses the academy's Public Works Department, Human Resources, and other supporting activities.

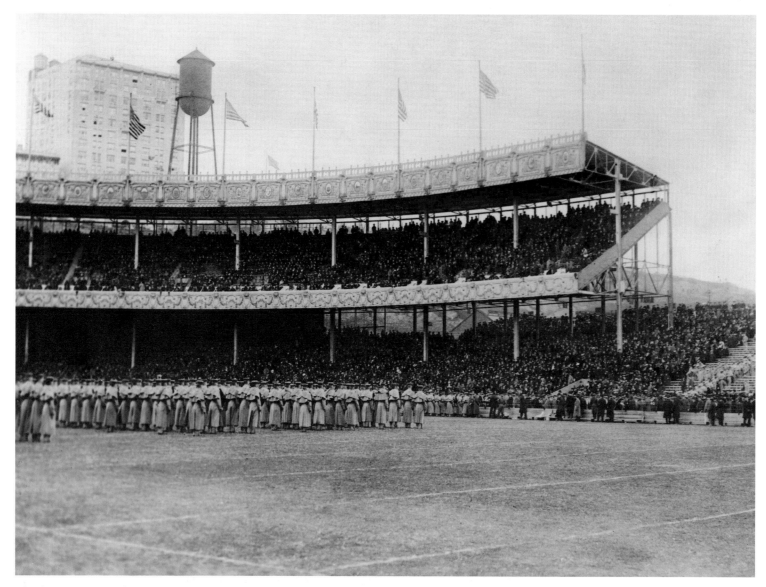

The first Army Navy football game was played at West Point in 1890. Navy won 24–0. The second game was played in Annapolis and Army won. In 1899, the game was moved to neutral turf at Franklin Field, Philadelphia. The vast majority of the games have been held in Philadelphia, but also in seven other venues, including New York's Polo Grounds shown here.

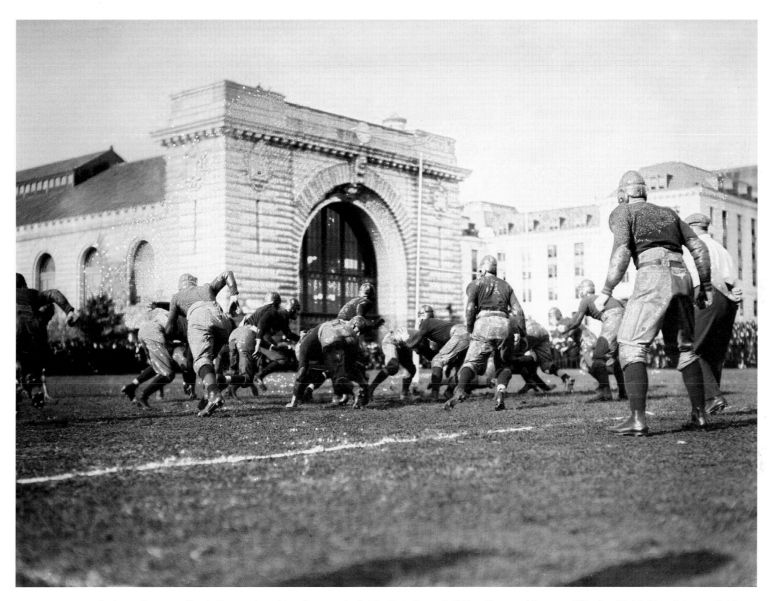

In its early years, football was played on the parade fields, first along Stribling Row and later on Worden Field. Navy's home field was moved to the seaward end of Dahlgren Hall about 1920. Steel beams, acquired from ships scrapped after the Washington Naval Treaty in 1922, were used to construct the bleachers. In 1931, after his death, the stadium was named for Robert Means Thompson, NA 1868, who had been a leading proponent of Navy athletics and the first U.S. president of the Olympics. Here Navy plays Georgetown University on November 6, 1920, winning 21–6. Georgetown had been the only team to defeat Navy in 1919, so it was sweet revenge.

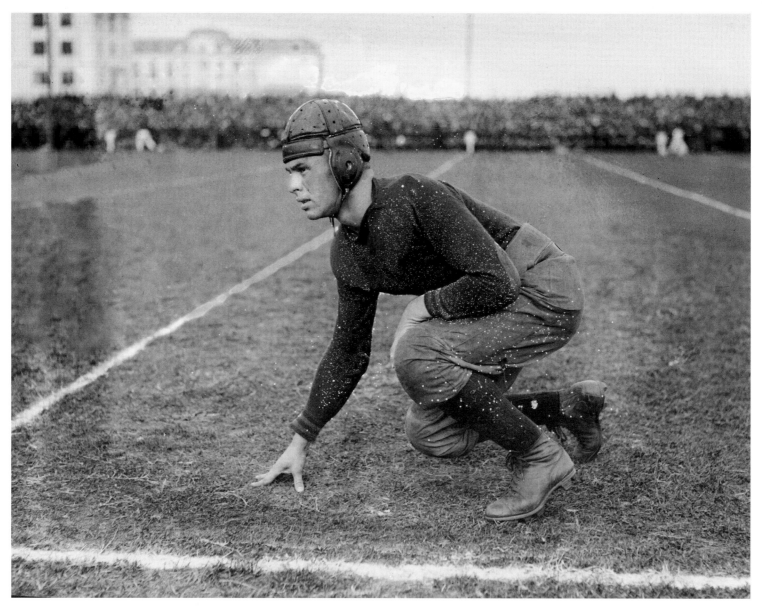

Midshipman Edward C. Ewen played right end and was elected twice as captain of the Navy football team, which had excellent winning records while he was captain, 7-1-0 in 1919 and 6-2-0 in 1920. His success on the gridiron translated into a long and distinguished career in uniform. He commanded two ships, including a carrier, in World War II; was decorated with the Navy Cross and Legion of Merit among others; and commanded a carrier division before he retired as a vice admiral in 1957.

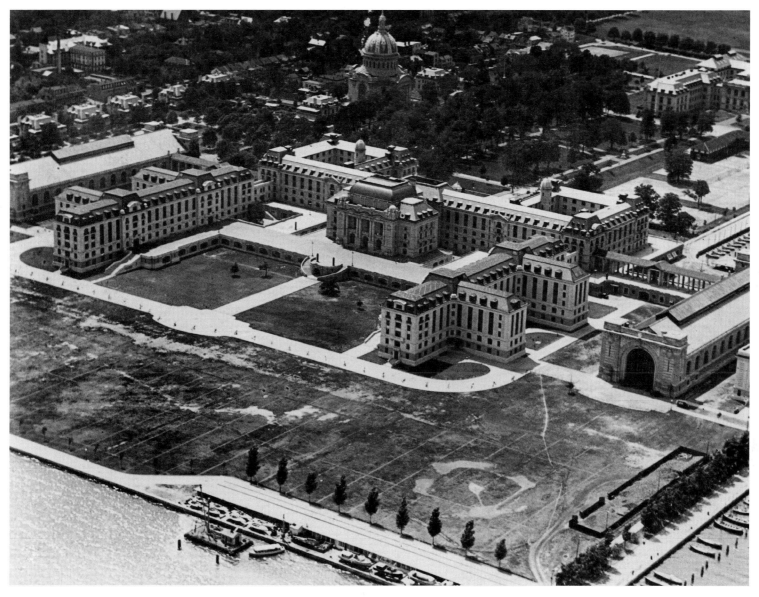

Architect Ernest Flagg's monumental beaux arts dormitory was named for George Bancroft, who, as Secretary of the Navy, founded the U.S. Naval Academy in 1845. The building was located so that it could be expanded as the school grew. Shown in this 1921 view are the new wings, numbered five and six, which were planned during World War I to accommodate the 300 percent increase in the Regiment of Midshipmen.

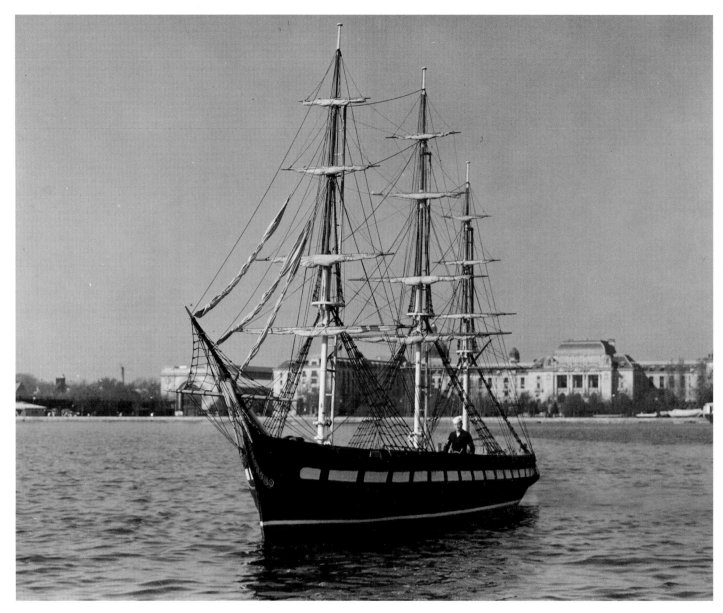

The real frigate *Constitution,* which had been assigned to the Naval Academy between 1860 and 1871, last visited Annapolis in early November 1931, during a post-restoration tour to major ports on both coasts. Five years later, Commander John F. Shafroth, then commanding officer of Naval Station, Annapolis, had his sailors build *Constitution, Jr.,* a working replica of the frigate. It was used for training and for a June Week reenactment of the Battle of Tripoli in Dewey Basin, complete with fireworks.

Built in 1939 as a medical dispensary, Leahy Hall was converted at the end of World War II for academics, serving the Department of Aviation until 1952 and then the Department of Language Studies until 1973. It was named for Fleet Admiral William D. Leahy, NA 1897, who served as chief of staff to the President and as chairman, Joint Chiefs of Staff, during World War II. Since 1973, Leahy Hall has accommodated the departments of Candidate Guidance and of Admissions.

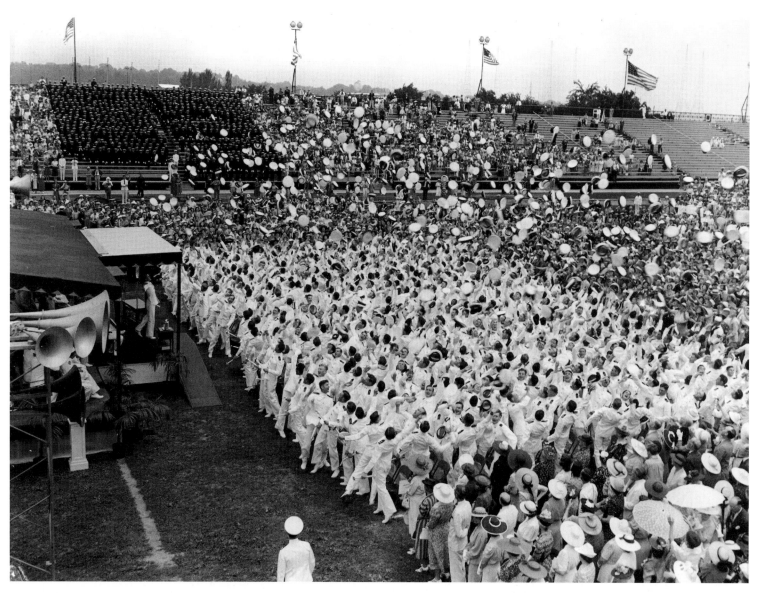

After the Civil War, when a midshipman graduated he had to serve two years aboard ship before he was commissioned an ensign, U.S. Navy, or a second lieutenant, U.S. Marine Corps. Because of the need for more junior officers, it was decided in 1912 not only to award a diploma at graduation ceremonies, but also to commission the new officers. The new officers no longer needed their midshipman hats, so they threw them up in celebration. The graduation exercises on June 1, 1939, were held outdoors in Thompson Stadium; Admiral William D. Leahy, then Chief of Naval Operations, was the featured speaker.

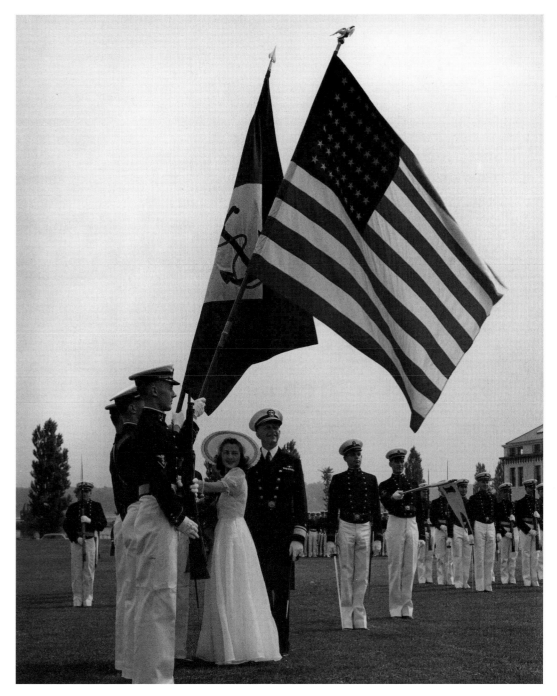

First Company, commanded by Midshipman William E. Heronemus, won the honor of carrying the flags in the fall parades. Heronemus selected Fay Ann Albrecht to be the "color girl," seen here with Rear Admiral Russell Willson, the Superintendent.

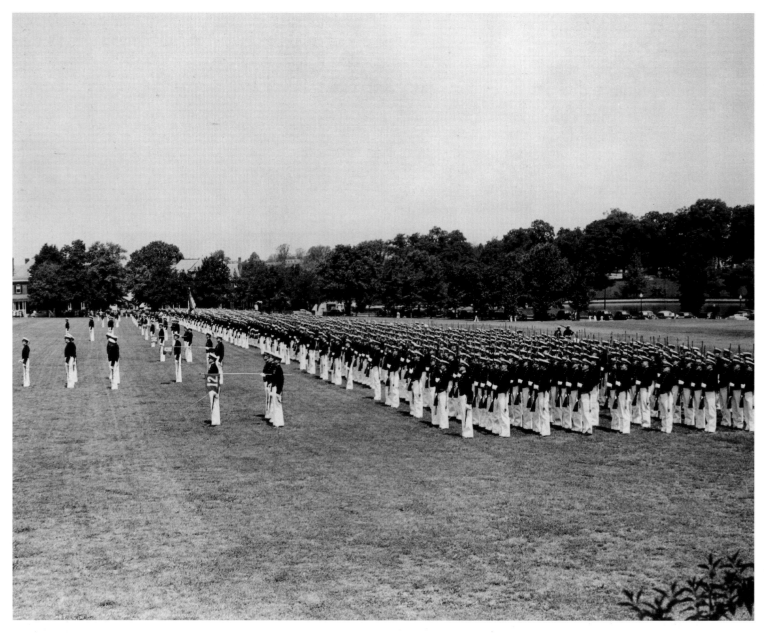

With war raging in Europe, the Class of 1941 was graduated early, in February, and had no June Week or color parade. The Class of 1942 had a color parade, on May 26, 1941, and would graduate on December 19, six months ahead of schedule.

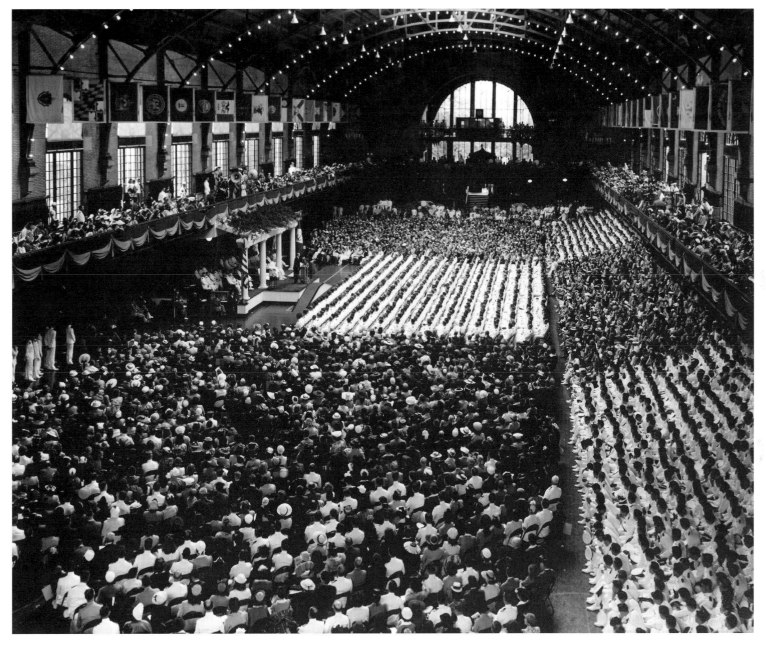

The Class of 1944 graduated in Dahlgren Hall on June 9, 1943. The old armory holds the record for hosting the most graduation exercises, nearly all of them between 1903 and 1957.

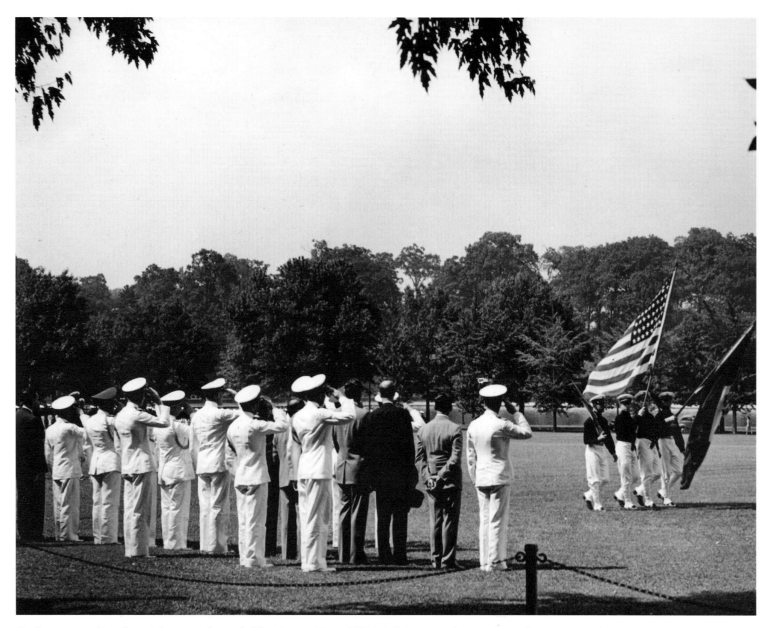

On June 11, 1943, a formal dress parade was held to honor General Higinio Morinigo, the president of Paraguay. As the color guard passed the reviewing party, the Navy flag was dipped and the officers saluted the national colors.

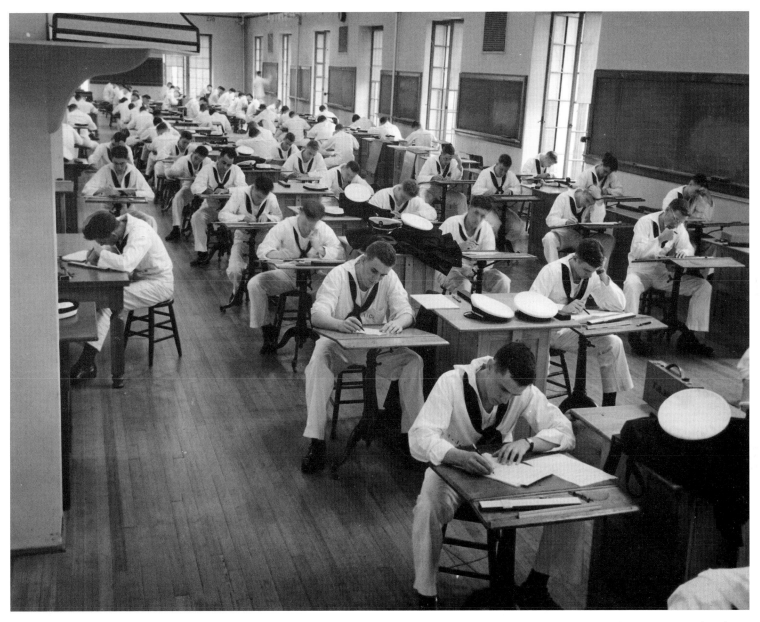

Class is in progress in 1944. During the war the size of the Regiment of Midshipmen required having larger sections of students. Sometimes it was even necessary, as in this case, for one large room to accommodate two classes at the same time.

Rear Admiral John R. Beardall, the wartime Superintendent, administers the oath of office to a naval reserve class in May 1942 in Dahlgren Hall. The reservists held undergraduate degrees from other colleges and sometimes specialties critically needed by the service. They went through a 90-day indoctrination program at the academy before being sent to assignments in the fleet or at other installations, hence their nickname "ninety day wonders."

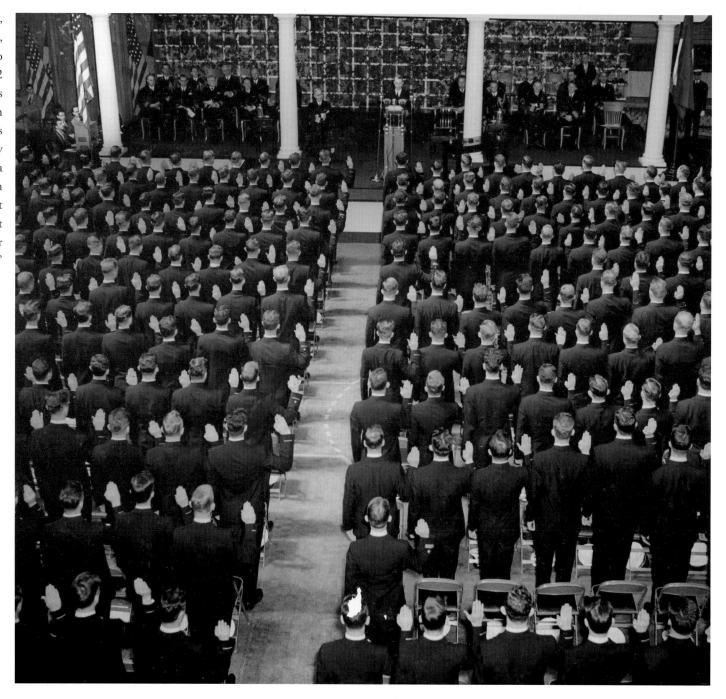

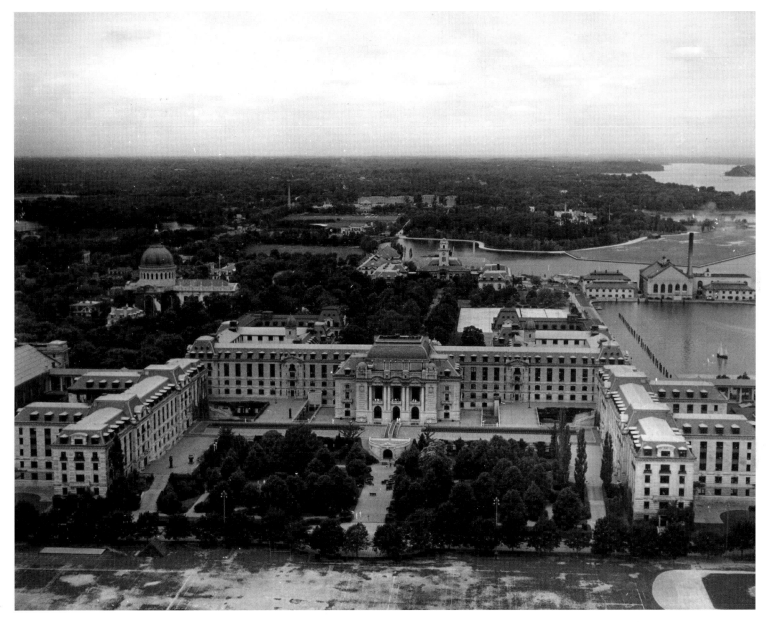

The World War II additions of first and second wings can be seen on the inside quadrangle, as can the new nave on the chapel. In the distance on the north side of Dewey Basin is the old power plant and shops for buildings and grounds.

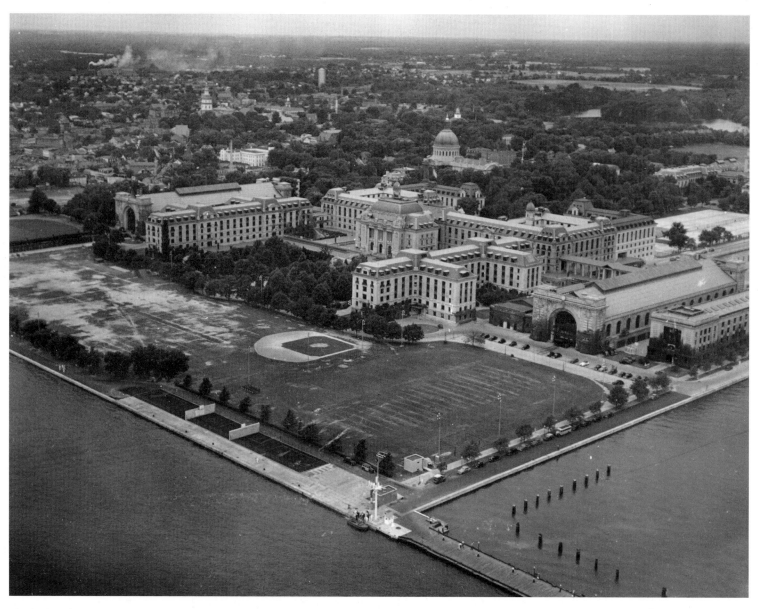

Flanked by Dahlgren Hall the armory and Macdonough Hall the gymnasium, Bancroft Hall is connected to them by roofed-over colonnades. Luce Hall is on the outside or river side of Macdonough. Also visible over the top of the armory in Annapolis is a large white building, Carvel Hall. Carvel was a leading hotel in the first half of the twentieth century, well known to midshipmen, their families, and their drags or dates, and other guests to town.

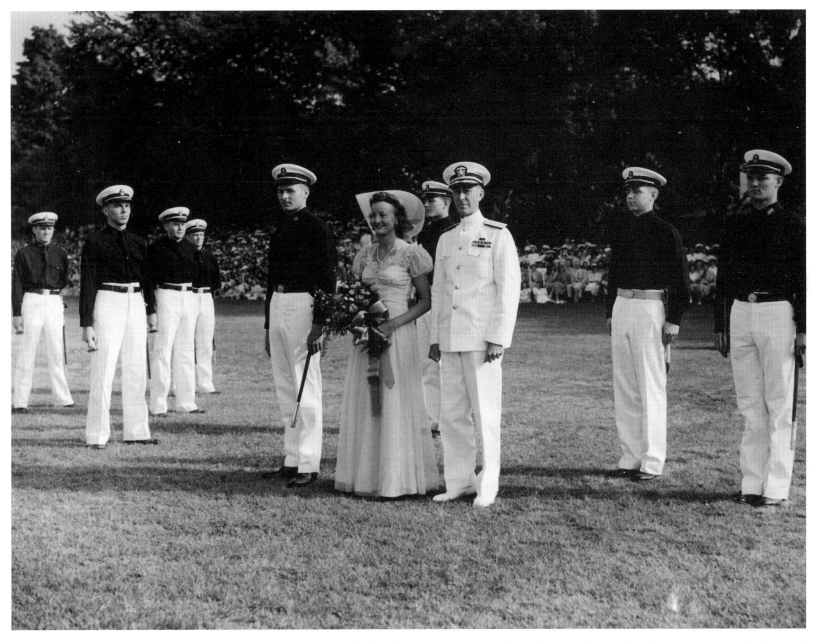

The 1944 color parade. Color girl Mary Jessup, Superintendent John R. Beardall, and 20th Company commander Robert B. Williams pose with the new color guard ready to receive the flags.

Following the graduation ceremony in Dahlgren Hall in 1944, the plebes snake-danced to Lover's Lane and boosted a classmate to the top of the Herndon Monument to show that they had conquered plebe year and were now youngsters.

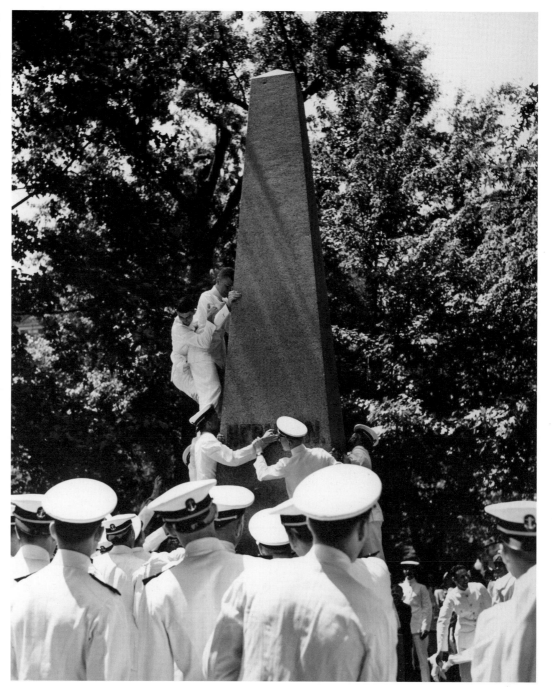

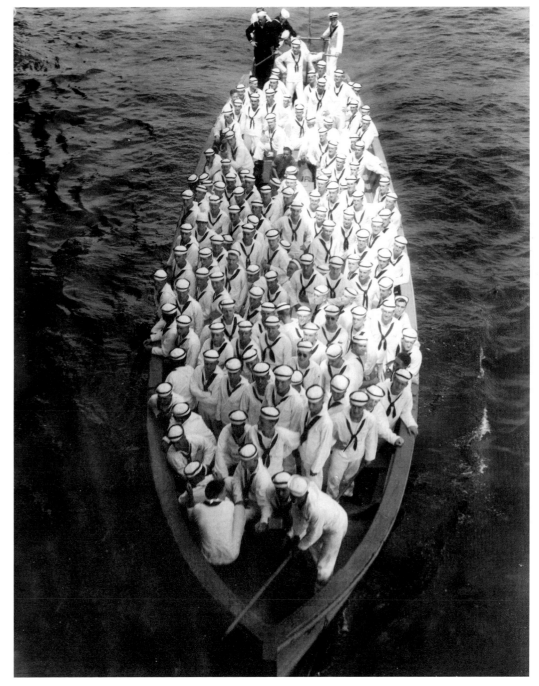

Safety regulations today would blow the whistle at this overloaded boat. Midshipmen aboard are being transported on July 30, 1944, to visit USS *Core* (CVE 13), anchored out in Annapolis roads. During the war, *Core* trained pilots in Chesapeake Bay between hunter-killer patrols in the Atlantic against German U-boats.

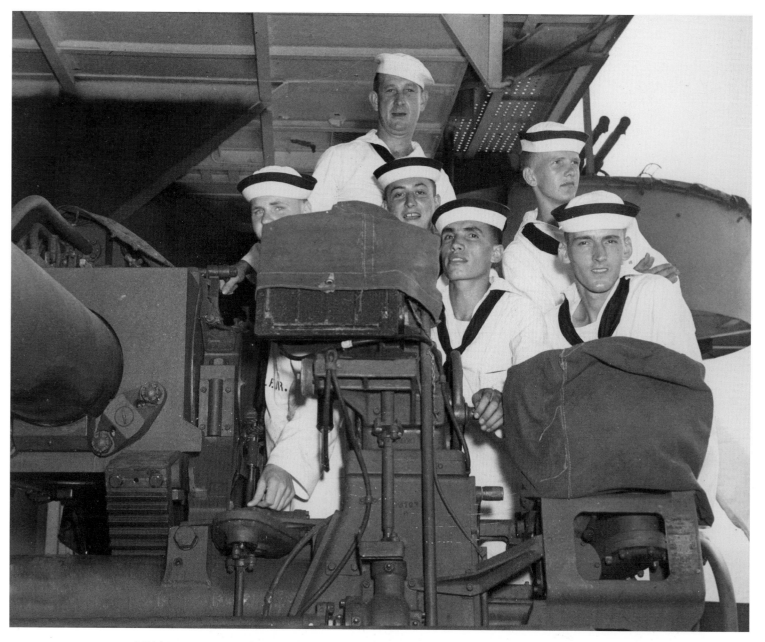

Midshipmen examine the range finder of a big gun aboard USS *Core,* a light carrier which saw extensive service in the Battle of the Atlantic in World War II.

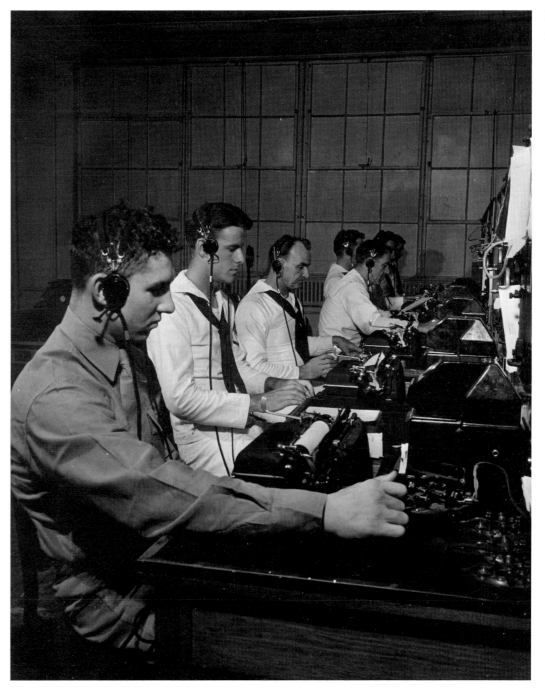

Midshipmen study communications and transcribing messages in this September 11, 1944, lab scene.

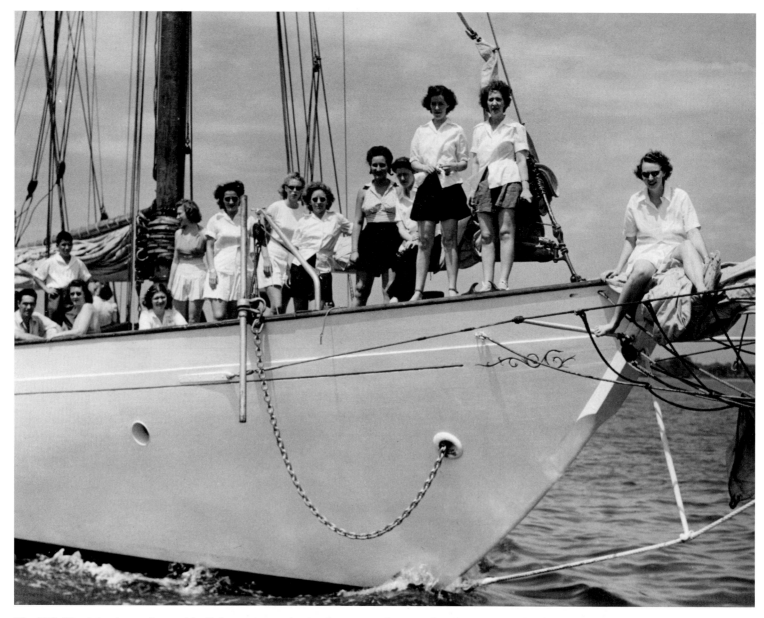

The U.S. Naval Academy, along with all the service academies, became coeducational in the summer of 1976. But some 11,000 yeomanettes served in the Navy during World War I, and Women Accepted for Volunteer Emergency Services (WAVES) numbered nearly 90,000 in World War II. Here a group of WAVES celebrate their second anniversary aboard an academy sailboat on July 30, 1944.

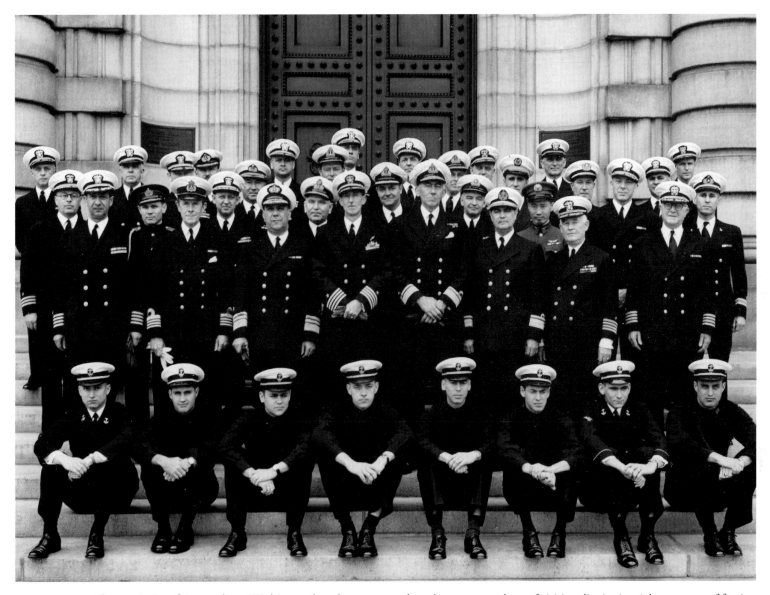

The proximity of Annapolis to Washington has always attracted an above-average share of visiting dignitaries. A large group of foreign naval attaches pose for a picture with their officer and midshipmen escorts at the main entrance to Bancroft Hall on April 4, 1945. Today the academy usually has seven or eight exchange officers from foreign navies on its teaching staff.

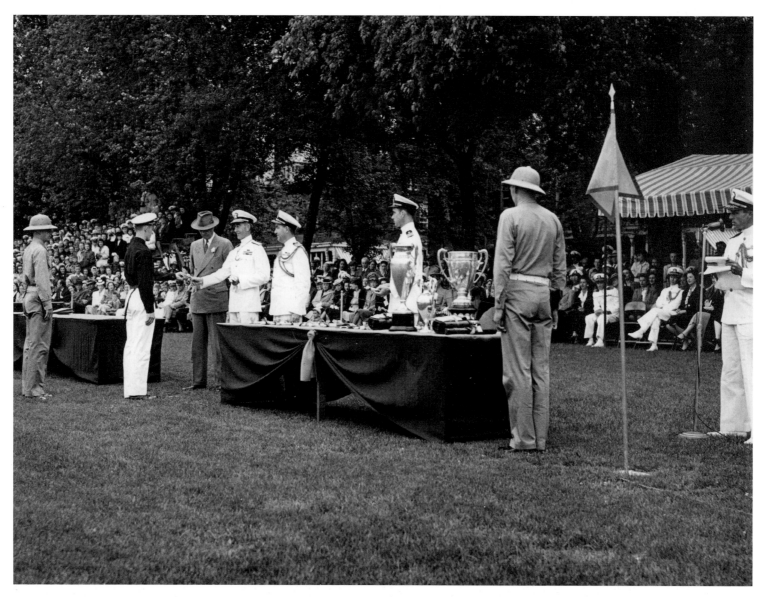

Alumni classes; civic, fraternal, and patriotic organizations; and the academy itself annually present a number of prizes and awards to members of the graduating class who have achieved distinction in leadership, in their class standing in a particular course of study, in athletics, and so forth. Two of the most coveted awards are the Class of 1897 Prize for leadership and the Thompson Trophy established in 1895 for the midshipman who has best promoted Navy athletics, both of which are represented by large, antique, silver trophy cups. This presentation is being held on June 4, 1945.

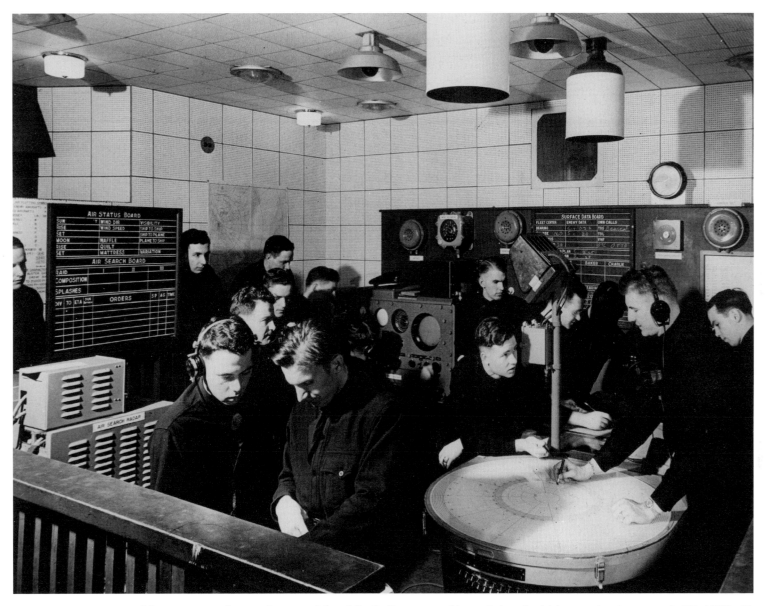

Midshipmen are studying radar, a crucial tool for finding enemy ships and aircraft which proved so important in World War II. The Naval Research Lab was important in the development of radar when it discovered continuous wave interference radar in 1922 and later pulse radar. The Navy coined the acronym "RADAR" in 1942 for radio detection and ranging.

Each weekday at 12:10 P.M., midshipmen conduct a formation in the courtyard in front of their Bancroft Hall dormitory. The band plays "Anchors Aweigh" and the "Marine Corps Hymn" and they all march by company unit to the mess hall for lunch. Today these formations are open to the public on most fair-weather weekdays.

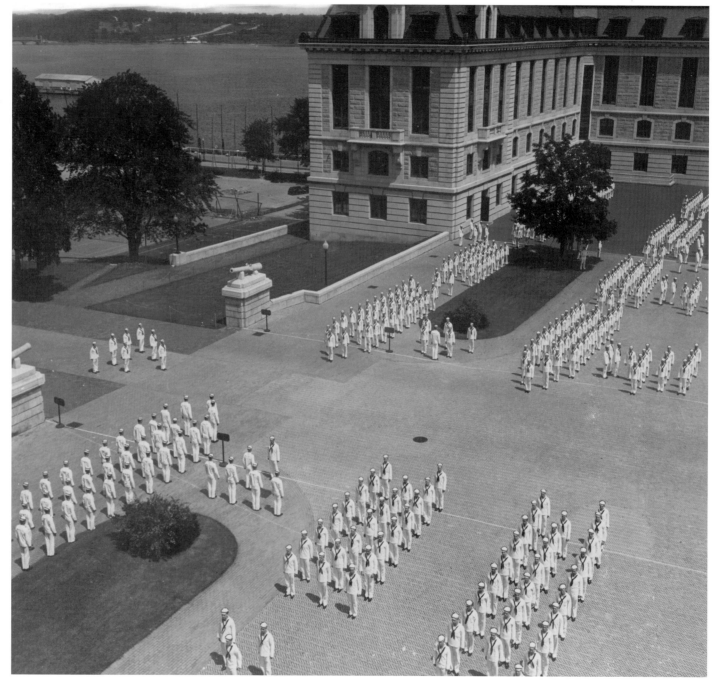

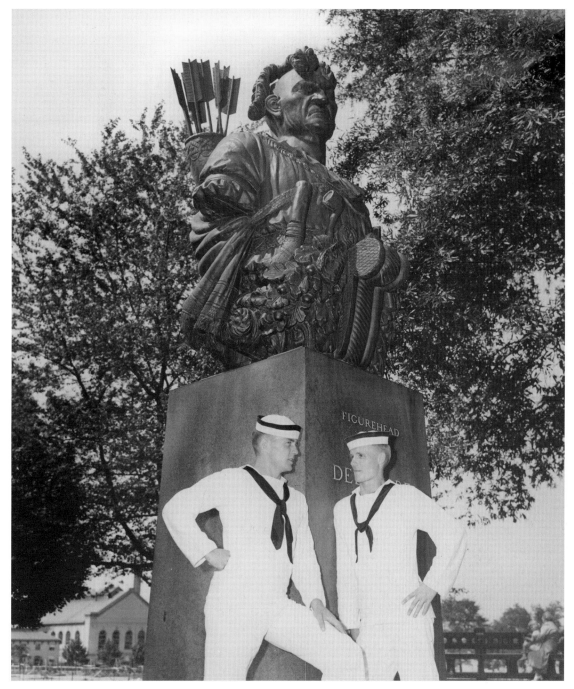

Two midshipmen chat at the bronze cast of the heroic-sized Native American known to them as "Tecumseh" and the "God of 2." He was originally carved in wood to represent Tamanend, Chief of the Delawares, and decorated the bow of USS *Delaware.* In 1868, the figurehead was sent to the academy and exhibited on a brick pedestal near the chapel. The mids, not knowing who he was supposed to be, gave him all sorts of nicknames. Tecumseh, for the famous Shawnee chief and warrior, became common parlance by the 1890s. For good luck, students throw coins at him on their way to examinations. (The original wooden figurehead is preserved indoors at the Visitors Center.)

Plebes are mustering in "T" or Tecumseh Court in front of Bancroft Hall in preparation for marching to class.

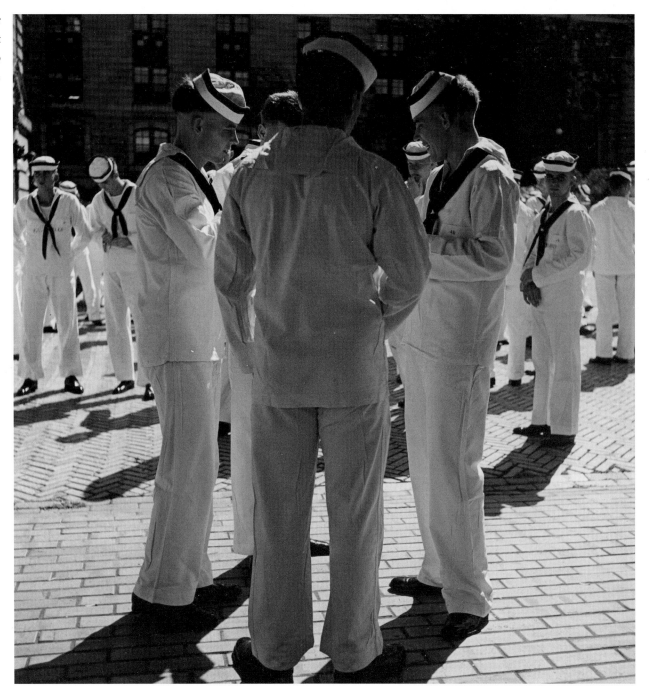

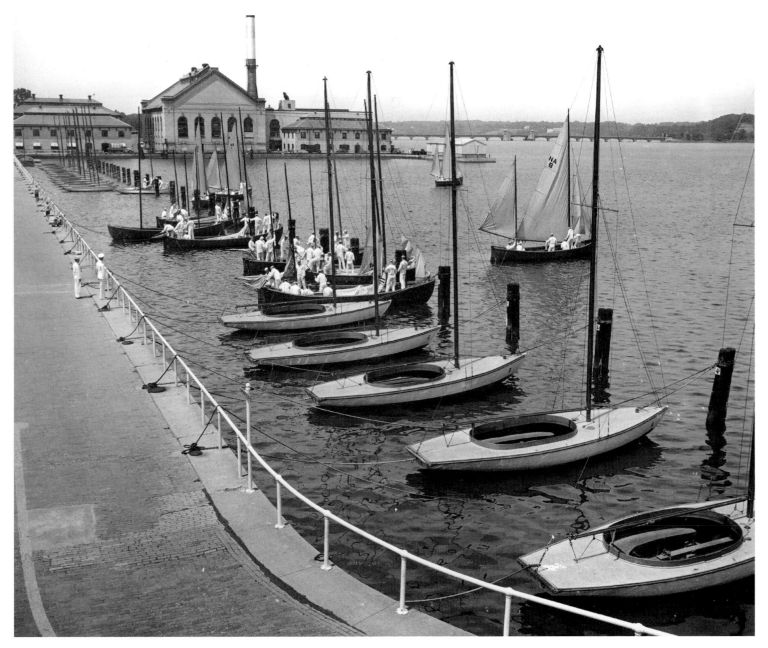

Midshipmen in view here are learning the skills of sailing in yawls and knockabouts in the protected waters of Dewey Basin, named for Admiral of the Navy George Dewey, NA 1858, the leader and hero of the Battle of Manila Bay.

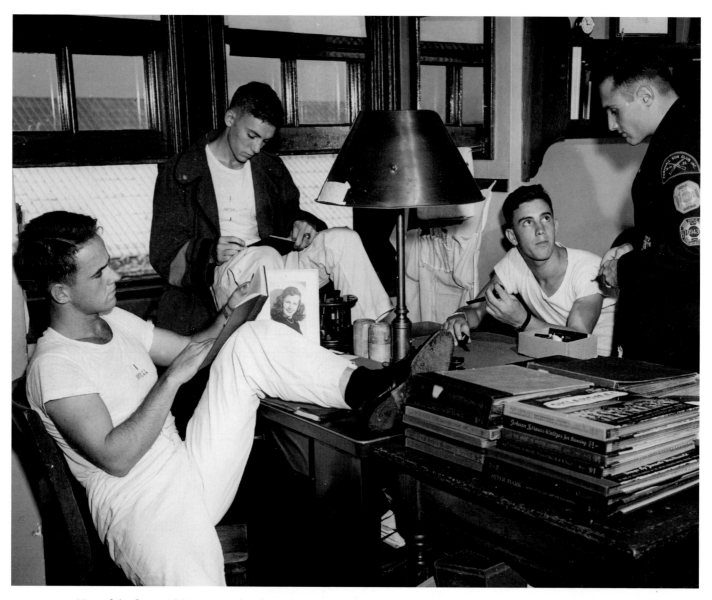

Two of the four midshipmen in this dorm room scene in September 1945 are foreign exchange students from South America. Today about 60 students from other nations attend the academy, with their home countries paying all expenses. Upon graduation they return home to serve in their own armed services. The first foreign student at the Naval Academy attended during the Civil War. He was Pierre "Pete" d'Orleans, a grandson of King Louis Philippe of France, NA Class of 1864.

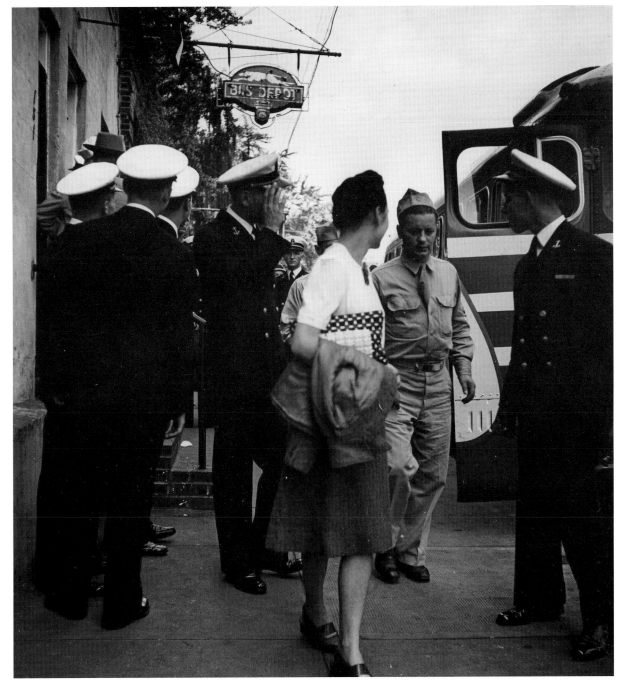

Although the rules on and amount of liberty for midshipmen to frequent the city of Annapolis and beyond have changed over the years, midshipmen have had town liberty since the founding of the school. Beginning in the second half of the twentieth century, families living within a reasonable distance of the academy could become midshipman sponsors and provide them a "home away from home" when on liberty.

With the Naval Academy's main gate three short blocks from Main Street, Annapolis, the "town-uniform" relations have always been close and amiable. Local merchants, particularly hotels, uniform, and tailor shops in the early years, and hotels, restaurants, and giftshops in more recent years, profit from the school and its many visitors. In return the town furnishes sports fans, cultural events, wives, and now some grooms, and a pleasant place to retire after a long naval career.

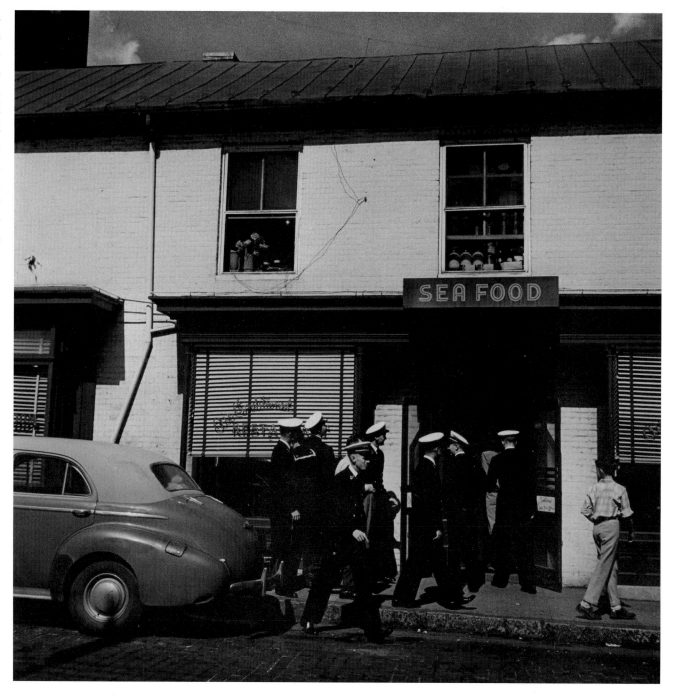

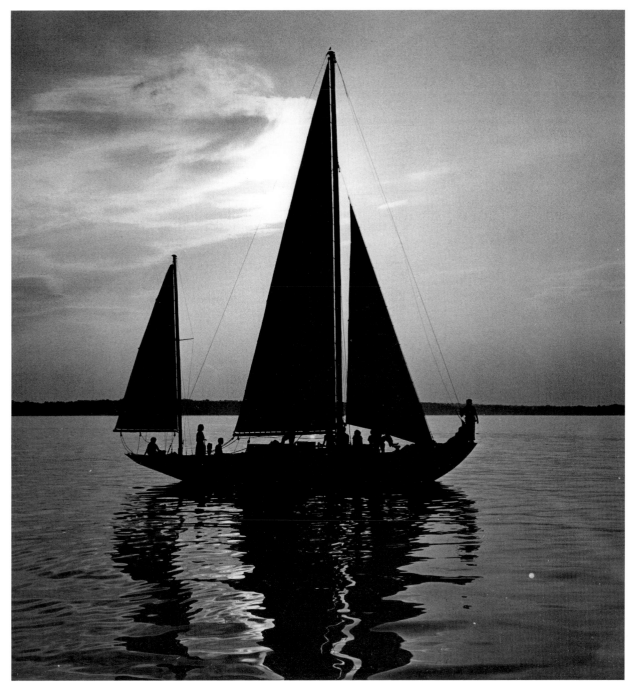

The academy has had many different types and sizes of sailboats during its history. Besides recreational weekend sailing, midshipmen are highly competitive in sailing, both on the intercollegiate level and in ocean races such as the Annapolis to Newport and Newport to Bermuda races. A number of really superior yachts have been donated to the academy for its sailing programs over the years, including the boats *Vamarie, Highland Light, Freedom,* and *Royono.*

Besides qualifying by age, marital status, citizenship, scholastically, medically, and having a nomination, before 1960 a candidate for the Naval Academy had to pass a very rigorous entrance examination administered by the academy. Over the years the exam grew in size and intensity so that it took two days to complete. A number of preparatory schools sprang up in the community around the academy in the late nineteenth and early twentieth centuries just to help young men prepare for the entrance examination. In 1960, the academy began accepting scores from the Scholastic Aptitude Test (SAT), administered by college boards, the same tests used by most civilian schools.

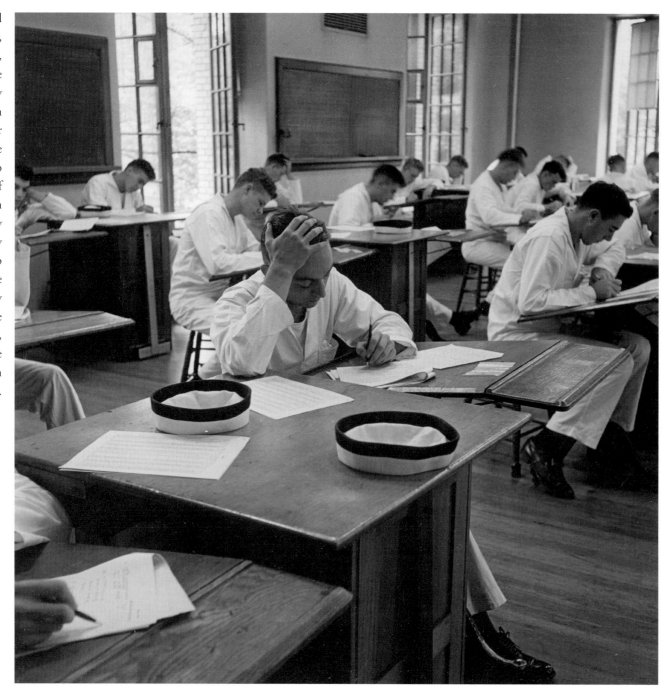

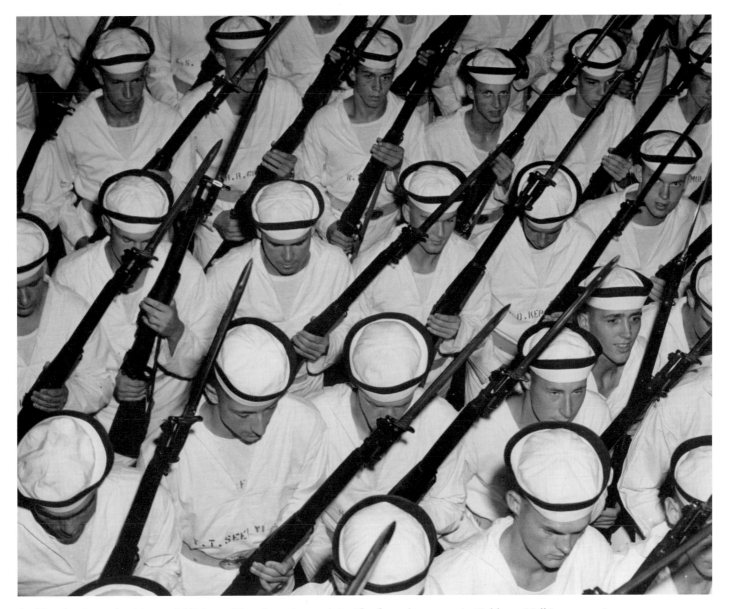

A plebe class in work whites and "dixie cup" hats have drawn their rifles from the armory in Dahlgren Hall in preparation for a practice parade in September 1945.

Knockabout sailing in Dewey Basin for young men from the nation's midsection is sometimes their first experience "at sea." It teaches them much, not just the rudiments of working the boat in the wind, but respect for the effects of tide, current, and wind upon the water and how to handle oneself in dire circumstances, such as a sudden afternoon thunderstorm on Chesapeake Bay, a frequent occurrence in the summer.

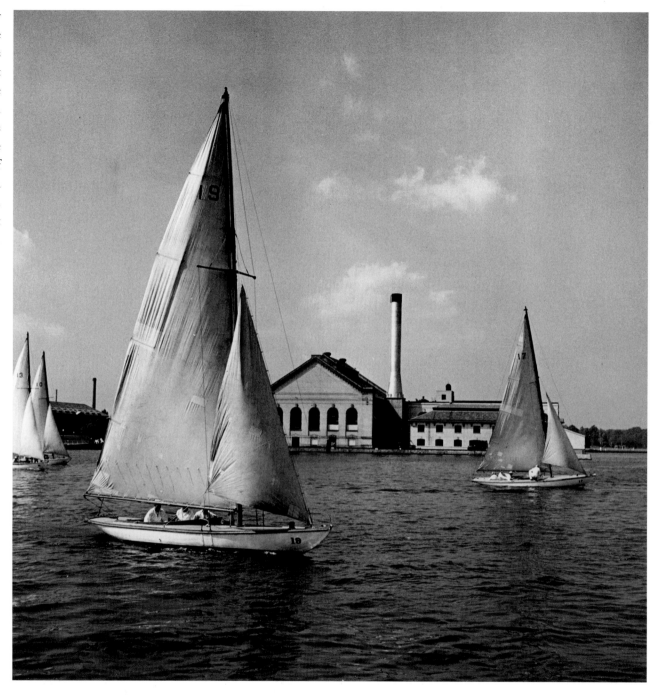

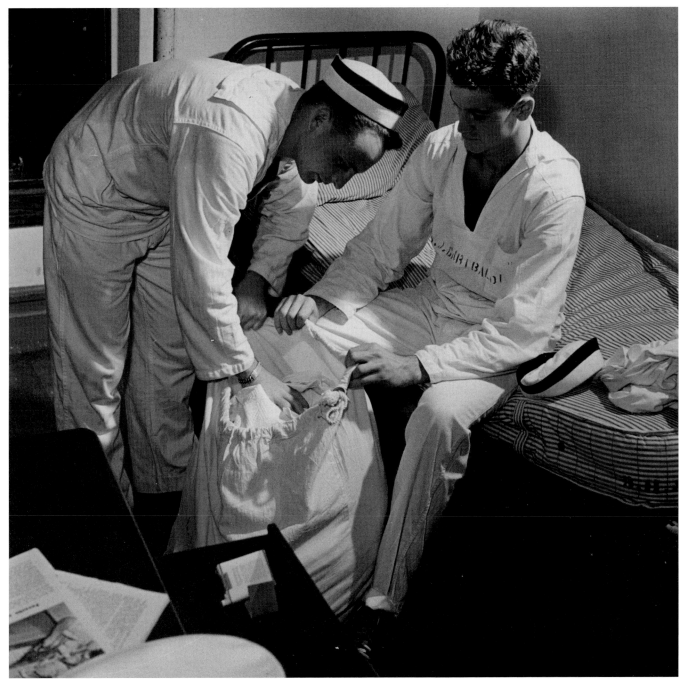

Two new plebes have reached their summer dormitory room and are starting to inventory their bag of newly issued items. In the early years of the school, individuals of the new class entered at different times over the summer. In more recent years the entire class comes aboard on Induction Day in late June. They are issued their new worldly belongings, given a hair cut, and are assigned to their summer letter-designated companies. In the evening, the entire new class is assembled in front of Bancroft Hall for a welcoming ceremony and for taking the oath as new members of the armed forces of the United States.

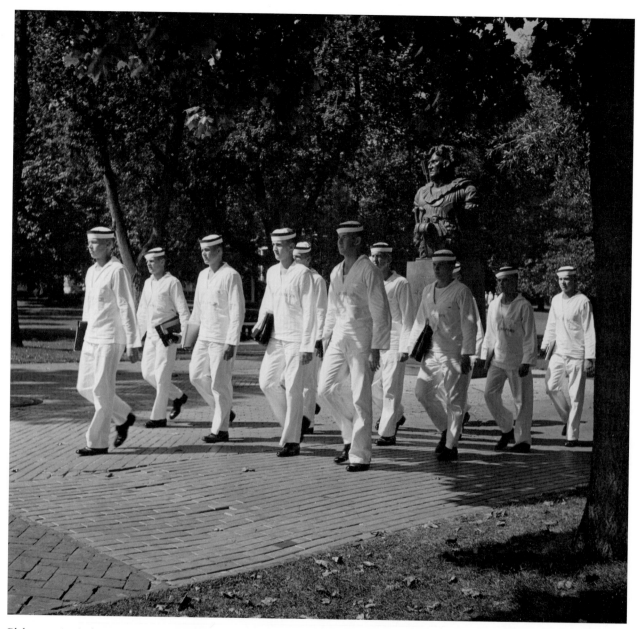

Plebes receive indoctrination training over the summer in various venues around the yard and are marched in formation to all their appointments. When the upperclassmen return from their summer assignments, the plebes are assimilated into the numbered companies for the academic year.

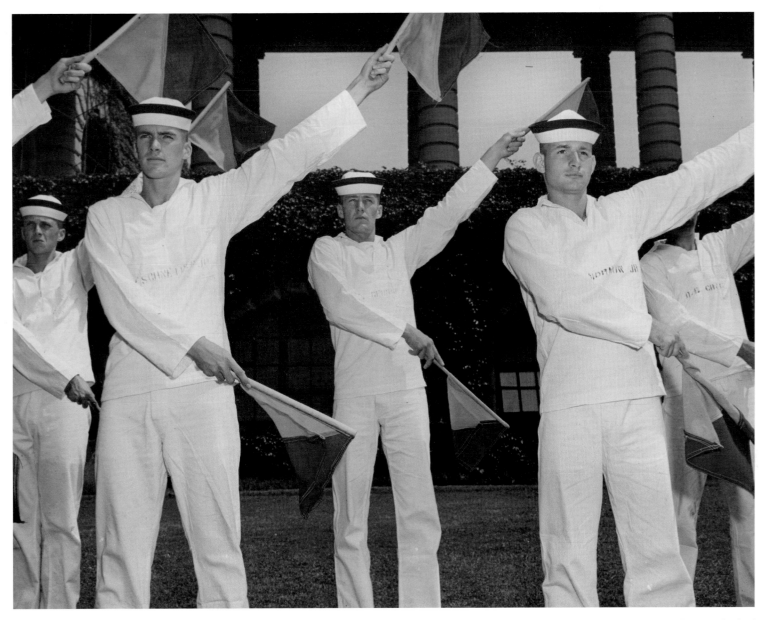

Midshipmen "in the old days" studied semaphore signaling. It proved easy for one of the fellows in this picture because he had already served two years in the Navy as a signalman. Each year about 200 sailors and Marines from the fleet are selected by the Secretary of the Navy to attend the Naval Academy. These "prior enlisteds," as they are known, often make the best officers.

The entire student body is assembled by company, battalion, and regiment; reports are rendered; sometimes a quick inspection of uniforms is made; the band or drum and bugle corps play; and the units march into the hall for lunch. Special guests of the academy view the ceremony from the top of the entrance steps while the public vantage point is opposite, at the entrance to the courtyard near Tecumseh.

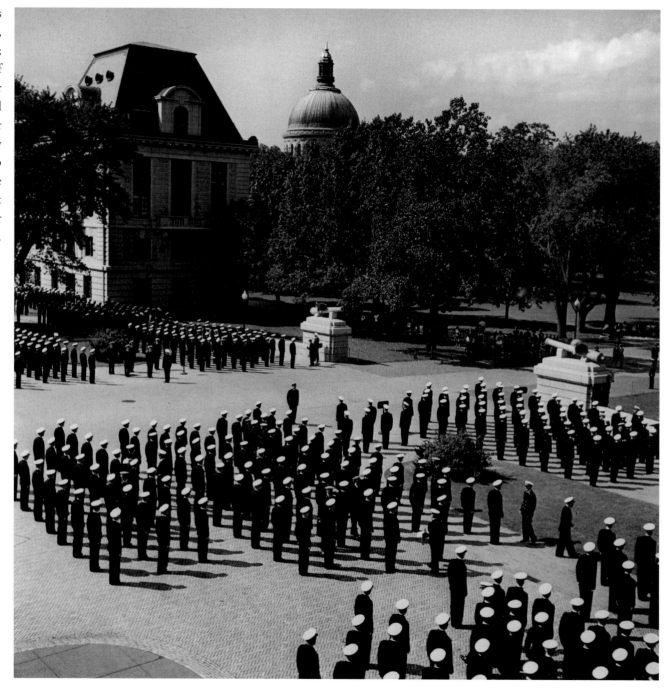

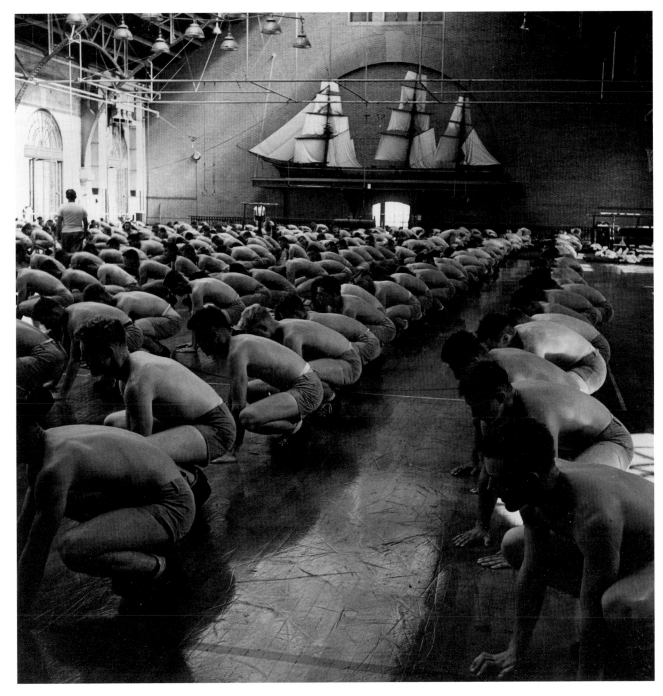

During plebe summer, the first order of business in the wee hours of the morning includes physical exercises or calisthenics. In good weather, they are usually held outdoors on Farragut Field. On perhaps a rainy day, this morning work-out is being held inside the gymnasium, Macdonough Hall. The large ship model of USS *Antietam,* in the background, presides over the activity.

Among the most popular sports in the Navy, probably because it is so easily accommodated aboard ship, is boxing. It was introduced to the academy by Admiral Porter immediately after the Civil War for competitions among the midshipmen themselves. The Brigade boxing champion remains a sought-after title. For many years, spectators at the Brigade boxing-championship matches attended in full formal dress. Civilian faculty were expected to wear black tie and tuxedo.

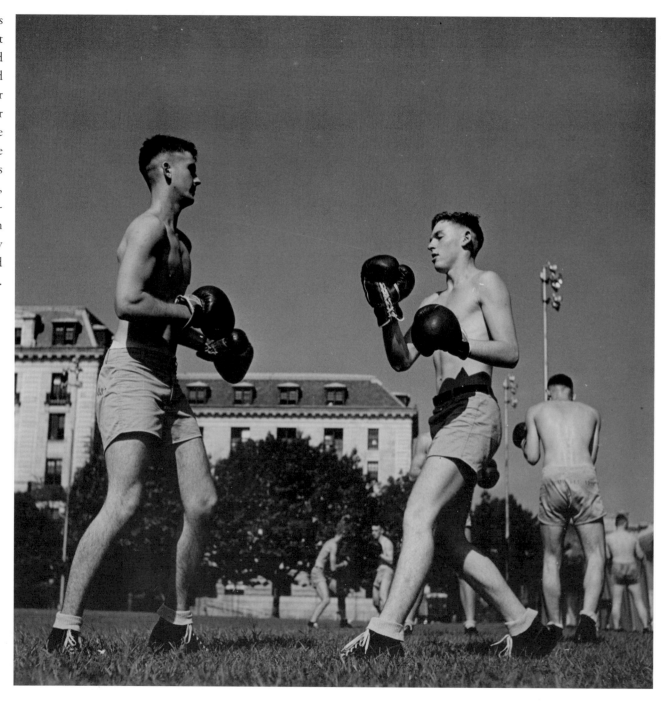

MODERN TIMES

(1948–1990s)

Boston ivy *(Ampelopsis tricuspidata)*, a native of eastern Asia and a climbing and clinging ornamental vine on stone and brick facades popular in the 1940s, engulfs the Administration Building in 1950. In the forties, the vine covered all the buildings of the Naval Academy and did serious damage to bricks and mortar, but also served, some perhaps thought, as camouflage in case of German or Japanese air raids during the war. It sure made the academy look like an "ivy league" school for a few years. Most of it had been removed by the late 1950s, but its stains can still be found on some buildings in the yard 50 years later. The Administration Building houses the office of the Superintendent, the equivalent of a college president, and his immediate staff. It is one of the few structures in the yard that remain named for their function rather than a great naval leader and hero.

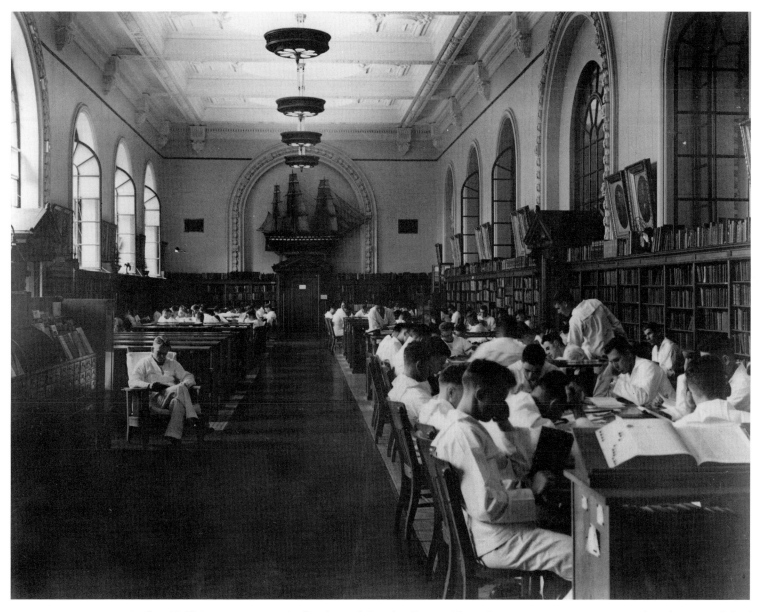

Mahan Hall's interior in 1950. Mahan housed the school's main library from 1907 to 1973, its principal reading room full of studious midshipmen shown here. The upper walls were lined with large, framed portraits of the former Superintendents of the academy, and at the ends were mounted large ship models of the frigate *Constitution* and ship-of-the-line *North Carolina.*

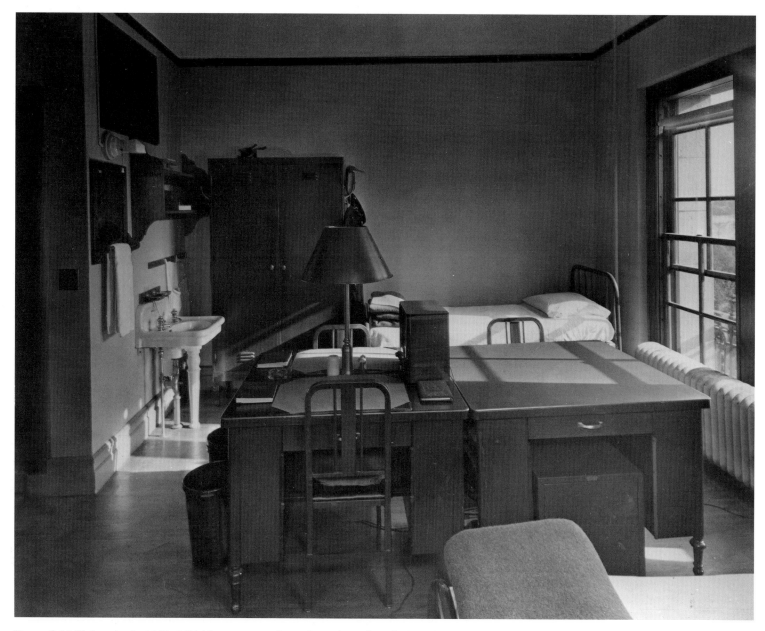

Bancroft Hall's interior in 1950. Midshipmen rooms have always been furnished modestly and efficiently. The basic furniture, beds, desks, chairs, wardrobe, and wash basin, and their organization in each dorm room remained much the same for the entire history of the school, until just recently.

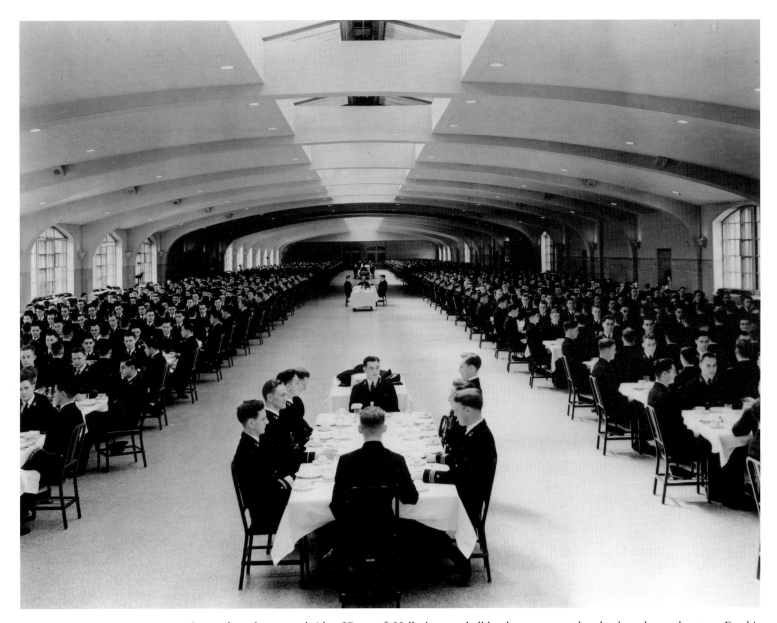

Located on the seaward side of Bancroft Hall, the mess hall has been renovated and enlarged over the years. Food is served family-style. Each company, which is made up of midshipmen from each of the four classes, dines together. The kitchens are amazing operations: two hundred 20-pound turkeys can be baked at one time and two tons of french fries fried at once. The interior is shown here as it appeared in 1940.

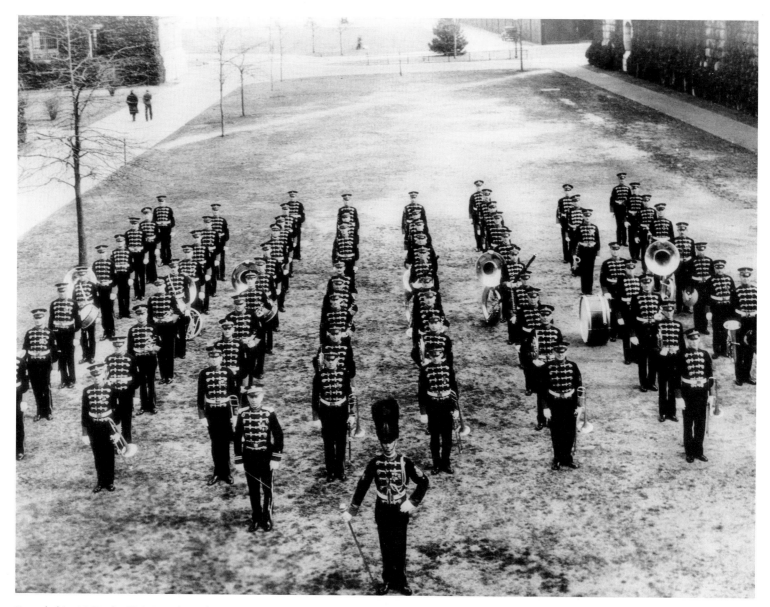

Founded in 1852, the U.S. Naval Academy Band, shown here in 1957, is among the oldest and busiest in the nation. Made up of professional musicians, it not only performs at all dress parades, noon meal formations, home football games, and ceremonies, it also plays at hops, balls, and other social occasions, and presents public concerts both inside the academy and during the summer in the city of Annapolis and elsewhere.

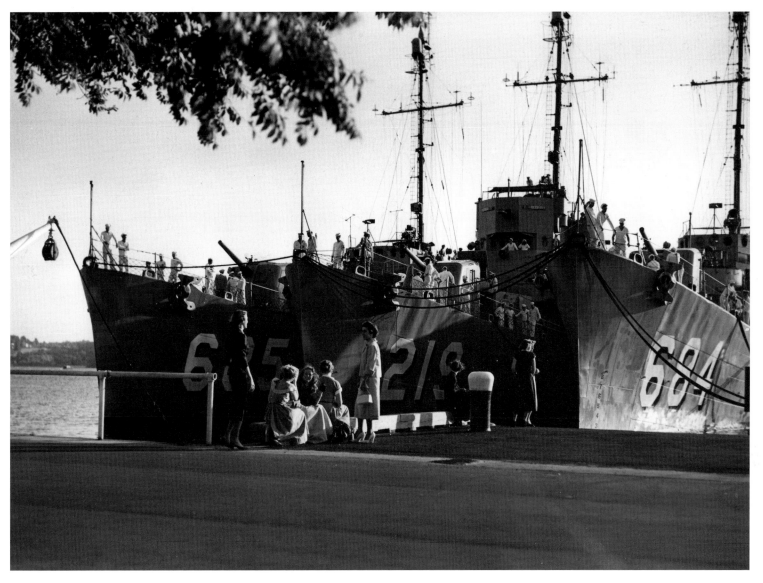

Each summer the midshipmen become familiar with "the real Navy" through cruises on board ships in the active fleet and by instructional visits to Navy and Marine Corps bases. Until 1958, active ships came up the Chesapeake Bay in early June to embark the midshipmen from the academy. The three destroyer escorts shown here, USS *Coates* (DE 685), USS *J. Douglas Blackwood* (DE 219), and USS *DeLong* (DE 684), are awaiting their summer complement in 1953. Today the midshipmen are flown to the ships in their homeports or at sea.

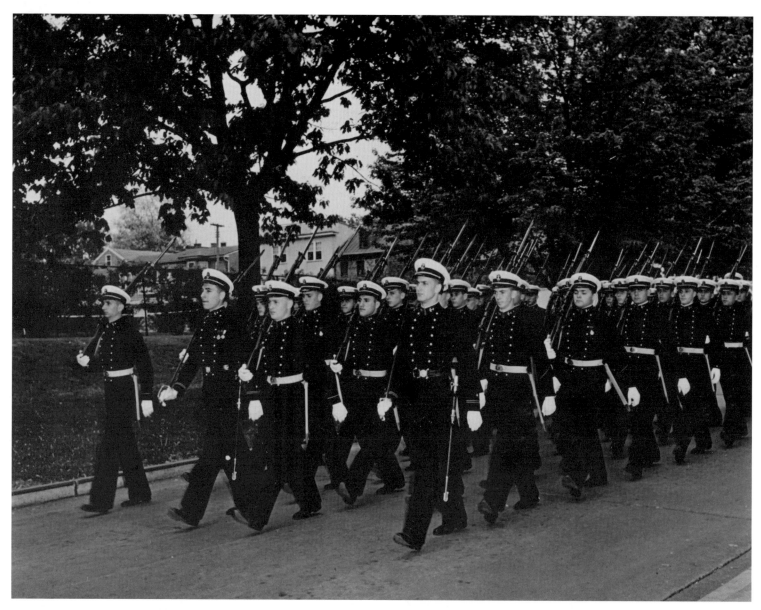

In impressive ceremonies, the midshipmen march by company in formal dress parades in the spring and fall on Worden Field. Usually there is a high-ranking Navy or civilian dignitary who has been invited to review the parade. Afterward the Superintendent hosts a reception so that the midshipmen leaders and guests to the parade can meet the dignitary. This dress parade is under way in 1950.

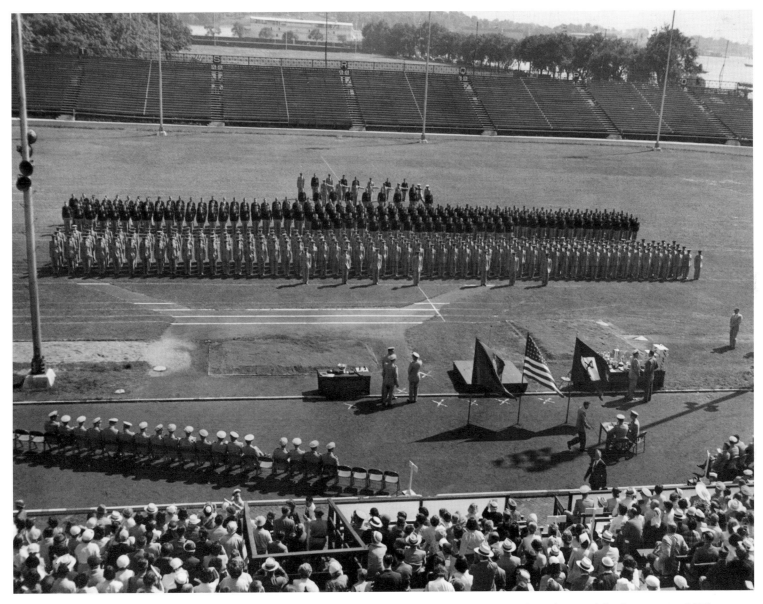

Numerous prizes and awards are presented during graduation week to both students and faculty. Here in old Thompson Stadium in 1953, the athletic awards are being given to those who have excelled in the 30-odd sports performed at the school. The most coveted is the Thompson Cup, awarded annually since 1895 to the athlete who has best promoted Navy sports over the past year. The famous football quarterback Roger T. Staubach won the honor for three consecutive years.

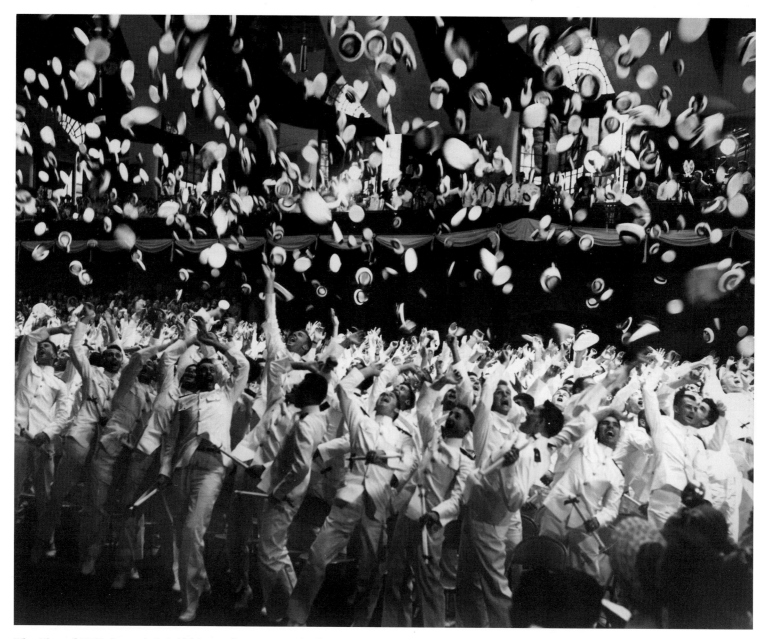

The Class of 1953 throw their midshipmen hats away in the final act of graduation on June 5, 1953. Among the 925 graduates that year were Admiral Carlisle Trost, who later served as Chief of Naval Operations, and H. Ross Perot, the famous business executive and presidential candidate.

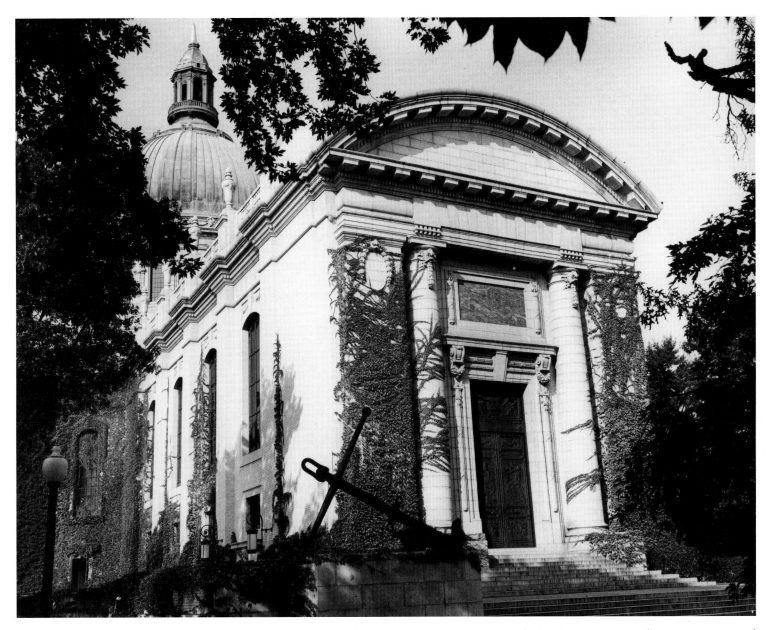

Besides housing daily and weekly religious services, the chapel is a place for baptisms, marriages, class reunion memorial services, organ concerts, and funerals. When services are not in progress, it is open to the public on a daily basis and is among the premier attractions for visitors to Annapolis.

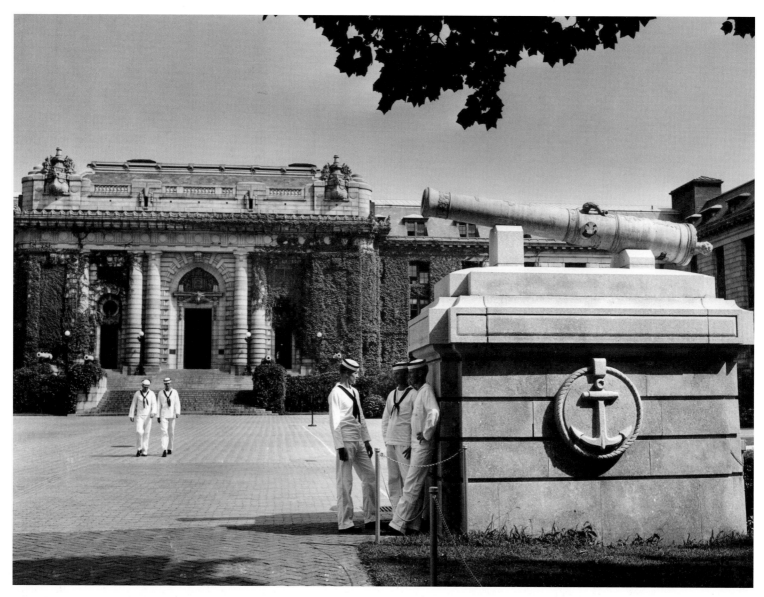

Bancroft Hall in 1954. "Mother B" is the affectionate name given the dormitory by its midshipmen residents. Among the largest college dorms in the world, its main section and eight connected wings have more than five miles of corridor. It has its own zip code and post office, department store, barber shop, cobble shop, laundry service, tailor shop, snack bar cafe, dining room, and other features. Virtually a small city, it houses more than 4,000 inhabitants.

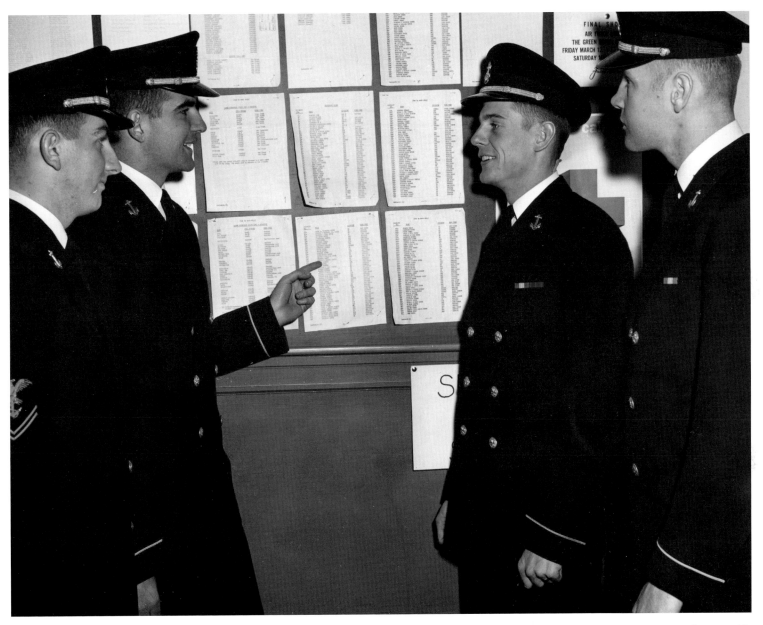

Before the era of computers, company area bulletin boards were an important means of communicating to students. Inside Bancroft Hall here in 1954, first-class midshipmen (seniors) learn their ship assignments as they prepare to begin their naval careers following graduation.

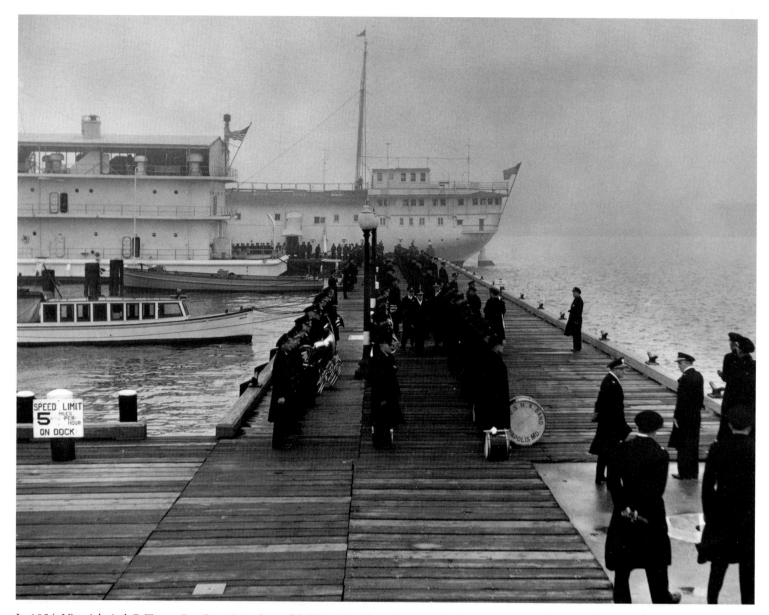

In 1954, Vice Admiral C. Turner Joy, Superintendent of the Naval Academy, inspects the Severn River Naval Command, the officers and enlisted personnel who reside aboard the station ship *Reina Mercedes* in the distance. The sailors performed a large number of tasks at the academy, from maintaining small craft to helping to police and protect the buildings and grounds. In more recent years, senior enlisted are assigned to each company of midshipmen to help mentor them on what life is like in the active fleet.

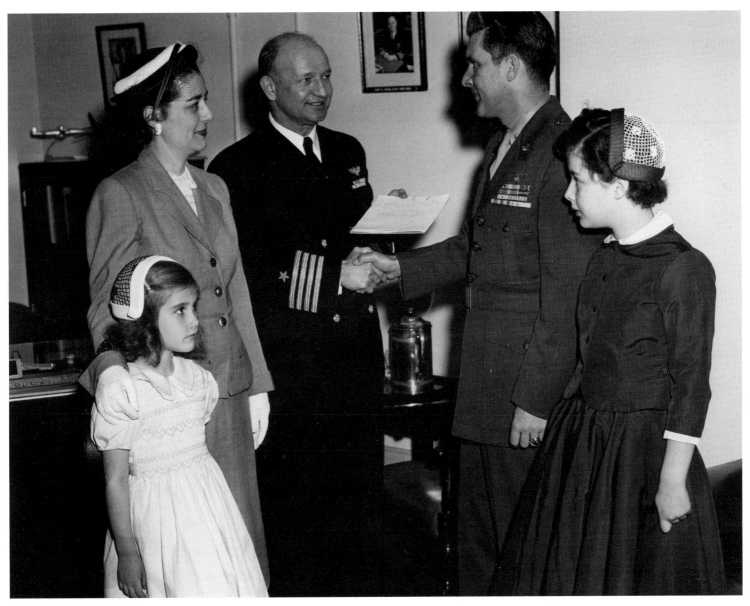

Many individual awards are presented to outstanding officers, sailors, and Marines each year. Here in 1954, Captain Prentis K. Will, USN, NA 1931, is awarding the Legion of Merit to Major William T. Herring, USMC, NA 1941, while Mrs. Mary Herring and his daughters look on. Colonel Herring was a highly decorated Marine officer with service in World War II and Korea. He was awarded, in addition to the Legion of Merit, the Distinguished Flying Cross, Bronze Star, Purple Heart, and Presidential Unit Citation, among others.

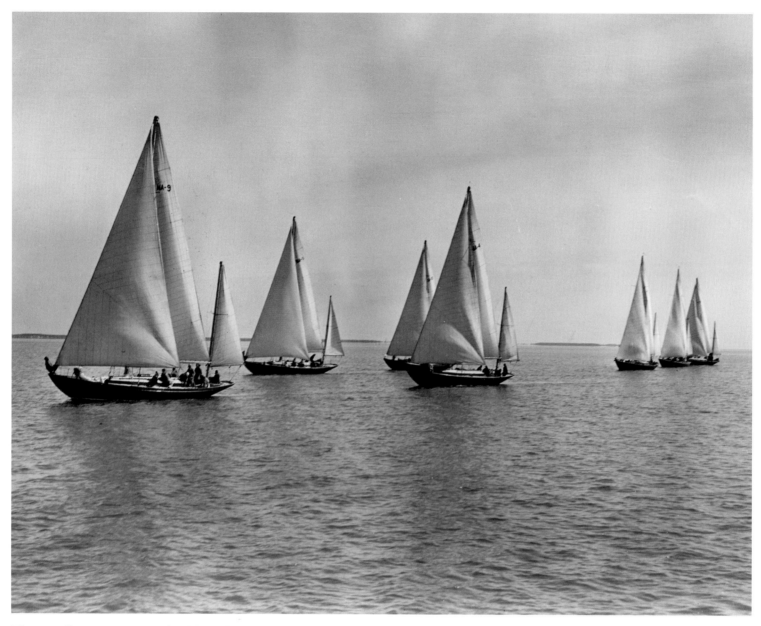

The McMillan Cup Regatta is the oldest collegiate sailing event in the United States, dating from 1930 and under way here in 1954. Navy has hosted the regatta since 1950 and has won the competition 12 times. Midshipman George Atkins, Jr., won it in 1955.

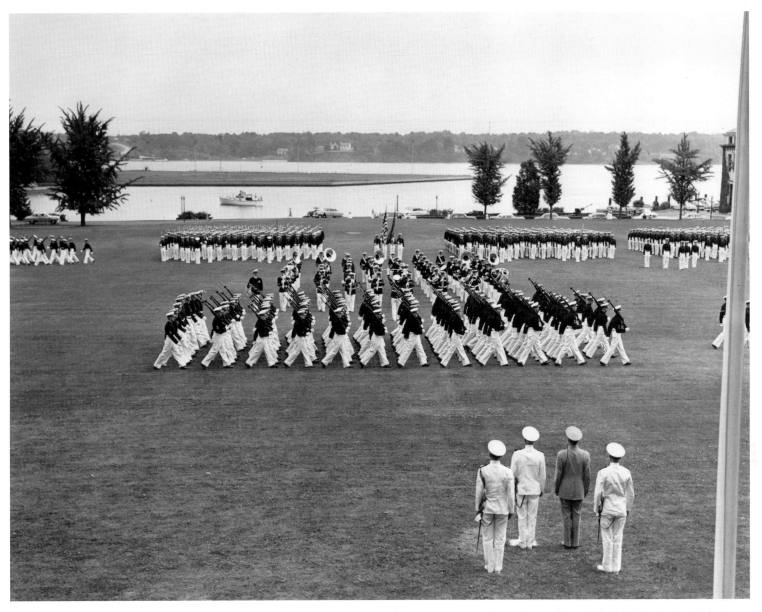

The guest dignitary reviewing the dress parade on May 29, 1954, was Major General Frederick A. Irving, U.S. Army, Superintendent of the U.S. Military Academy, accompanied by Vice Admiral C. Turner Joy, Superintendent of the U.S. Naval Academy, Captain Charles A. Buchanan, Commandant of Midshipmen, and the admiral's flag lieutenant. College Creek and the Severn River in the background provide a magnificent and appropriate view from the Navy's formal parade field.

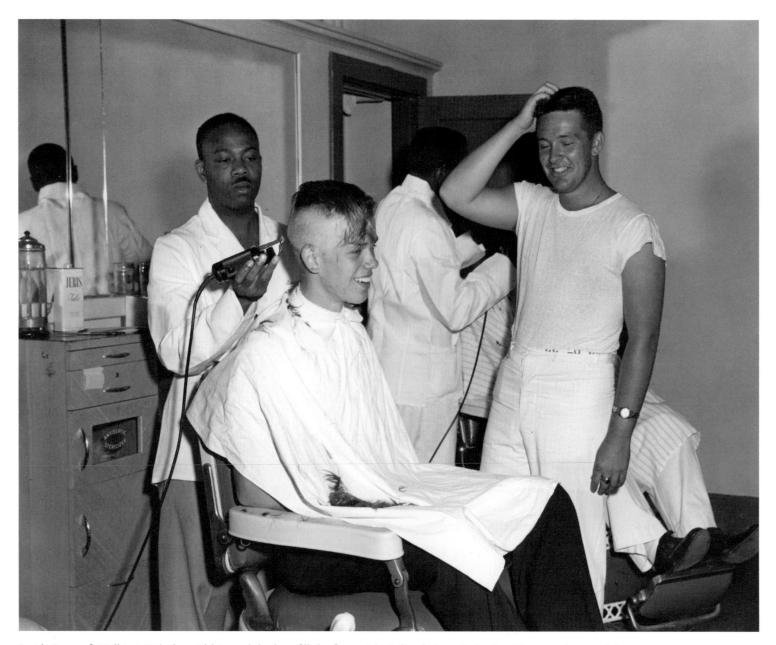

Inside Bancroft Hall in 1954, the midshipmen's barbers fill the floor with civilian hair on Induction Day as each new plebe (freshman) is shorn of his unnecessary locks to start him in his role as a U.S. Navy midshipman.

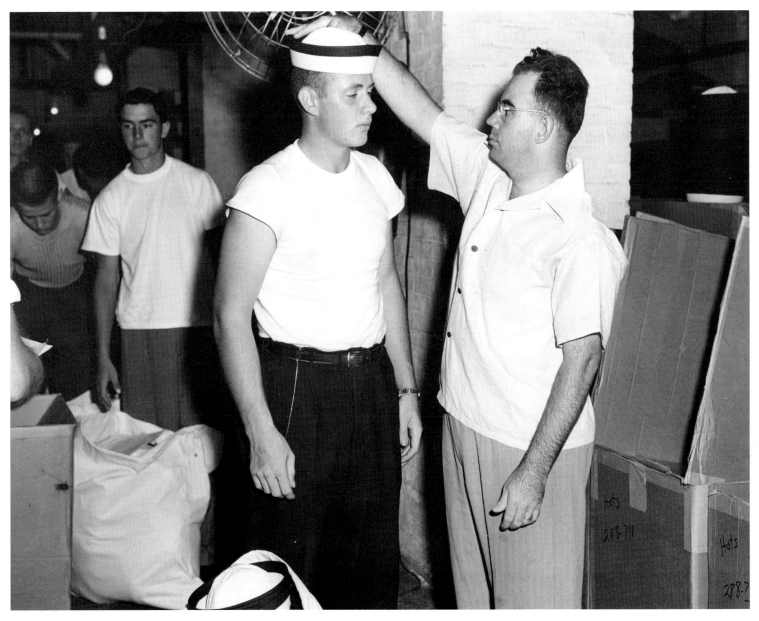

A new midshipman is a college freshman, and at the service academies, a plebe, from the Latin *pleb* or *plebeian* for the common people or lower class. Here Roderick J. Pejsar, NA 1958, is being fitted for his "dixie cup" hat in 1954, which he wore only during plebe summer and which helped identify him as a "lowly plebe."

First and third class midshipmen, seniors and sophomores, raise their hats in farewell on June 5, 1954, as USS *Macon* (CA 132) departs the Annapolis roadstead for the summer training cruise. The Class of 1955 *Lucky Bag* yearbook shows pictures of Spain, Portugal, France, Holland, and Belgium, as they made a grand tour of Western Europe while studying all the stations aboard the cruiser *Macon*.

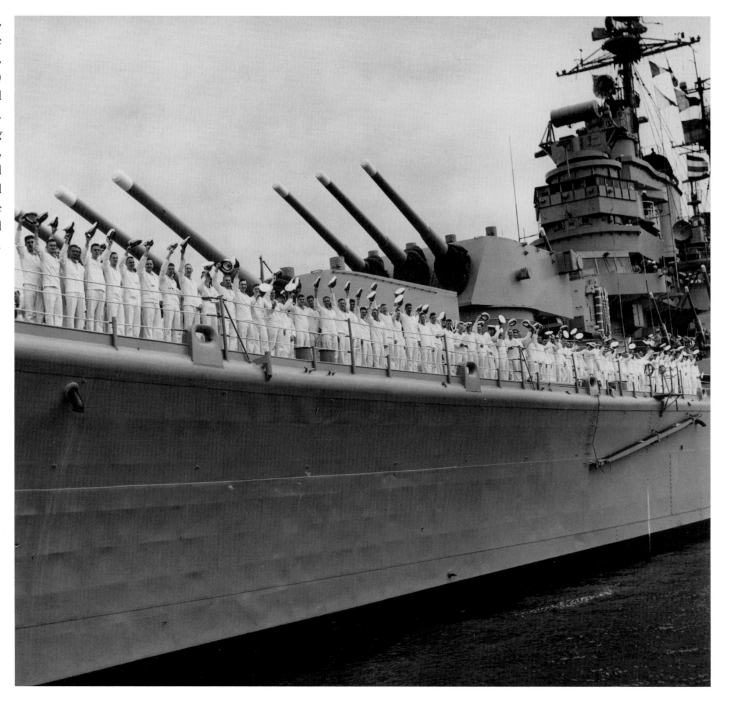

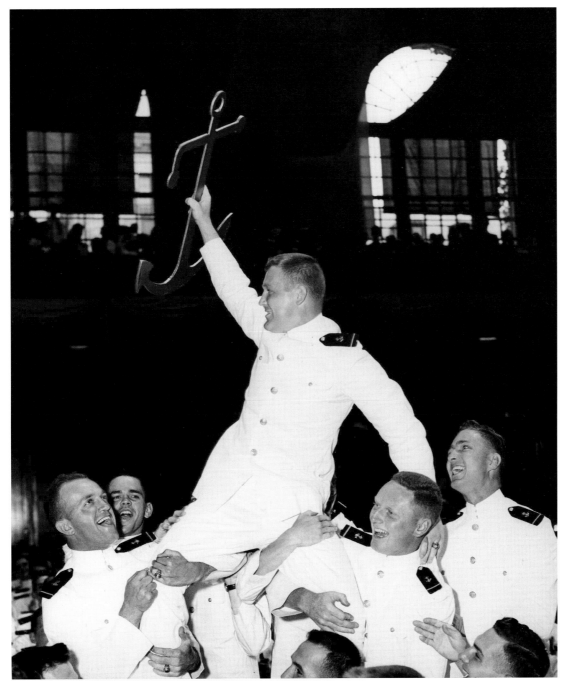

During graduation ceremonies, an academy ritual for many years was hoisting up the "anchor man," the student at the bottom of the class in overall academic standing and the last to graduate. It is a position coveted by those knowingly less-than-stellar scholars, because it is also tradition that each classmate contribute one dollar for the "anchor man," a nice reward in a large class. Many "anchor men" have had very successful naval careers, some 17 of them making flag rank, an admiral.

On July 1, 1954, Vice Admiral C. Turner Joy was relieved as Superintendent by Rear Admiral Walter F. Boone in a change-of-command ceremony held in the courtyard in front of Bancroft Hall. Known to the students as "T Court" or Tecumseh Court after the nearby figurehead of ship-of-the-line *Delaware,* the site has hosted many ceremonies in its time including the visits of Presidents, the inaugurations of Secretaries of the Navy and Chiefs of Naval Operations, and the inductions of many new classes of plebes as they take their oaths.

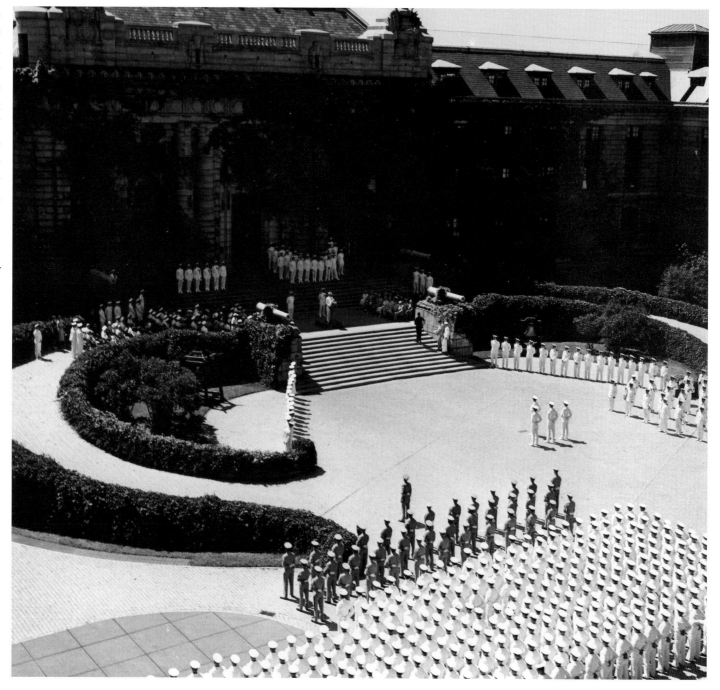

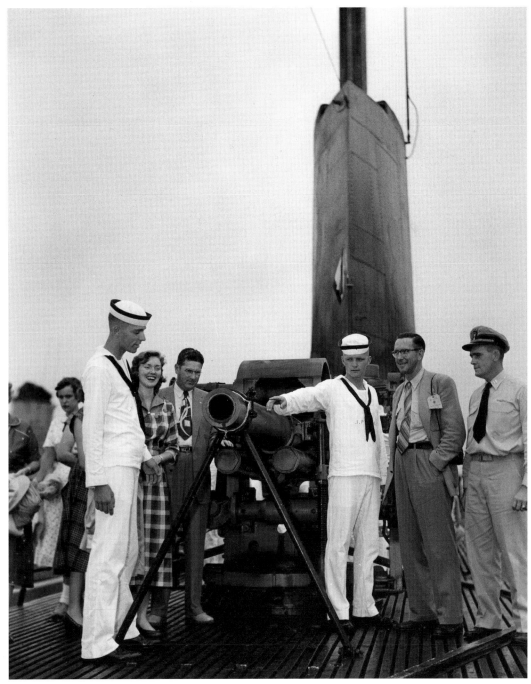

Plebe summers have been concluded since 1951 with Plebe-Parent Weekend during which parents, other relatives, and friends of the freshman class come to town to marvel over the dramatic changes in their midshipman. If nothing else the loss of weight, gain of muscle, loss of hair, and gain of posture are startling to the parents, regardless of how much knowledge they have already learned about the Navy and its college. The special weekend, along with homecoming in the fall and graduation week in the spring, are the times of visits by modern ships of the active fleet. Here Midshipman 4/C John Paul Price, NA 1958, explains what he has learned about the 5-inch gun on USS *Runner* (SS 476).

Two alumni of the academy are examining the operation of a television camera during an open house held at Homecoming in September 1954. Television was a rather new training aide at the school in those days. In the years ahead all classrooms would have television monitors and the ability to hook into the academy's central television network and studios. As in most colleges, Homecoming each fall attracts thousands of alumni for a weekend visit, class reunions, and a football game.

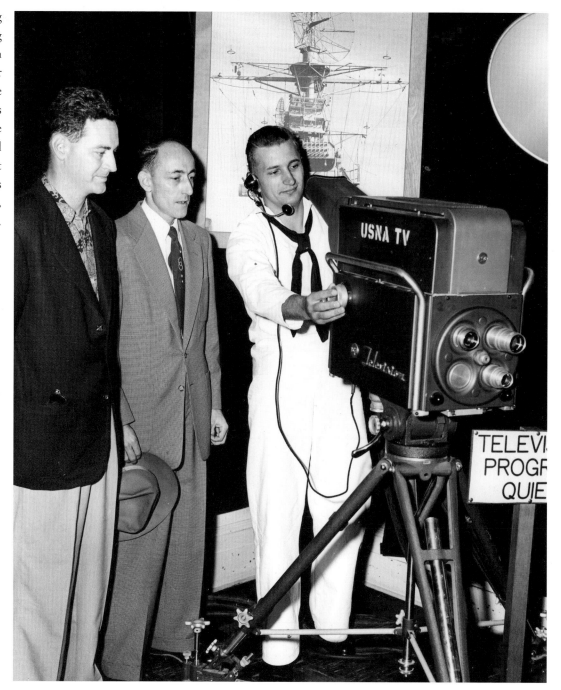

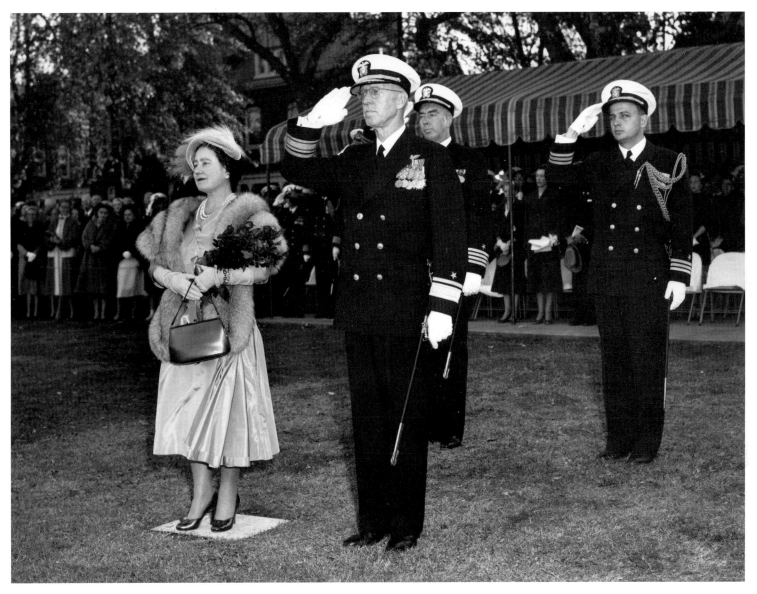

Many dignitaries have visited the Naval Academy over its history including presidents, kings, princes, cabinet members, admirals, generals, and other famous folks like Samuel Langhorne Clemens (Mark Twain) and Amelia Earhart. Among the most prestigious visits was that of Queen Mother Elizabeth of Great Britain on November 8, 1954. Here her royal highness reviews a parade on Worden Field accompanied by the Superintendent, Rear Admiral Walter F. Boone, Commandant of Midshipmen, Captain Robert T. S. Keith, and the admiral's flag lieutenant.

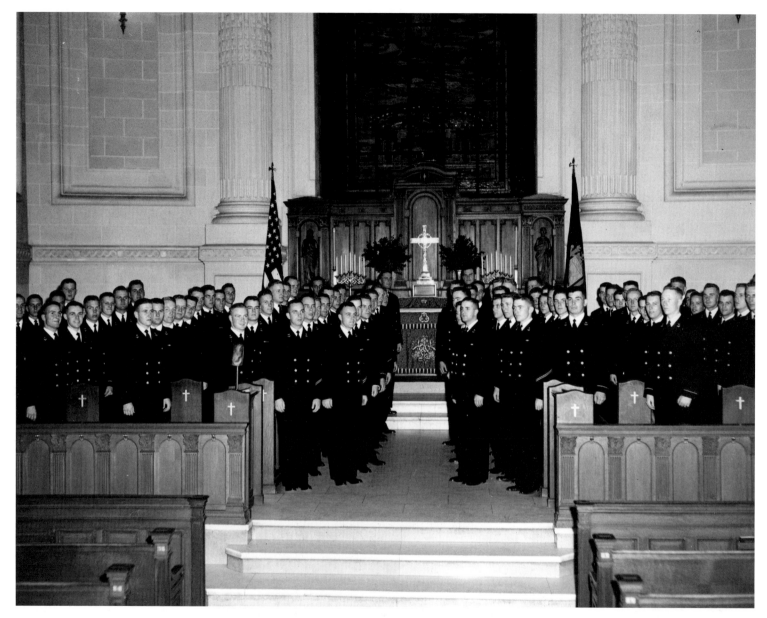

Midshipmen chapel choirs date from the nineteenth century and have been rehearsed and accompanied on the chapel organs by bandmasters such as Charles Zimmermann and by professors such as Joseph W. Crosby, Donald C. Gilley, John Barry Talley, and currently Monte Maxwell. This choir poses for a photograph inside the Chapel.

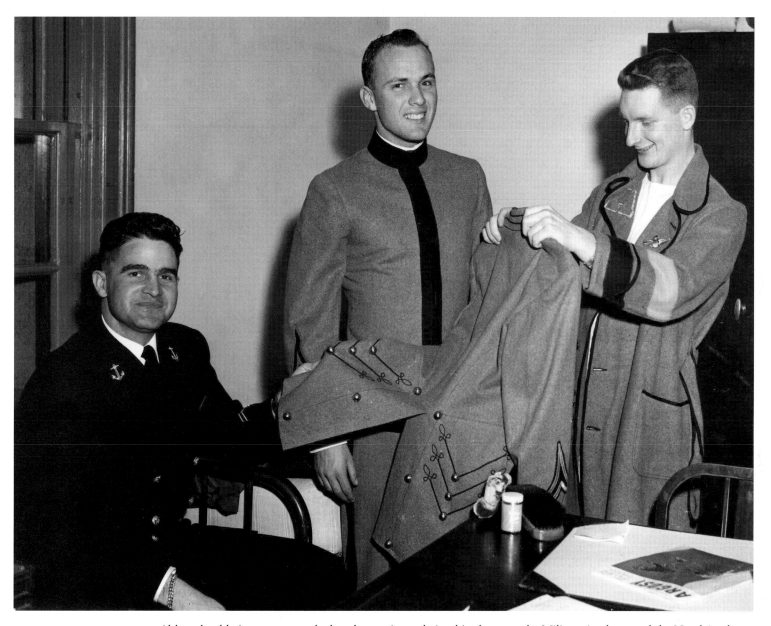

Although athletic contests are the best-known interrelationships between the Military Academy and the Naval Academy, there have been and continue to be many others. Exchange weekends, this one taking place in 1955, were eventually extended to exchange semesters among all the service academies.

During exchange semesters in the academic year today, there are always a few cadets in their unique uniforms from West Point, Air Force, and Coast Guard walking to classes and marching in dress parades at the Naval Academy. This image was recorded in 1955.

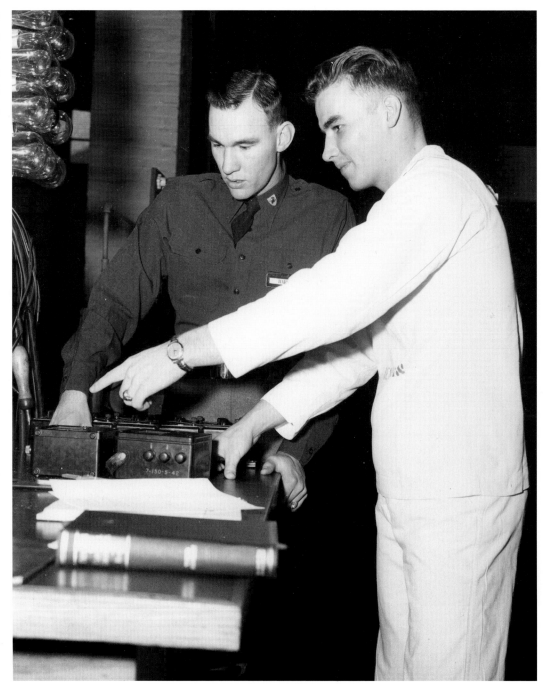

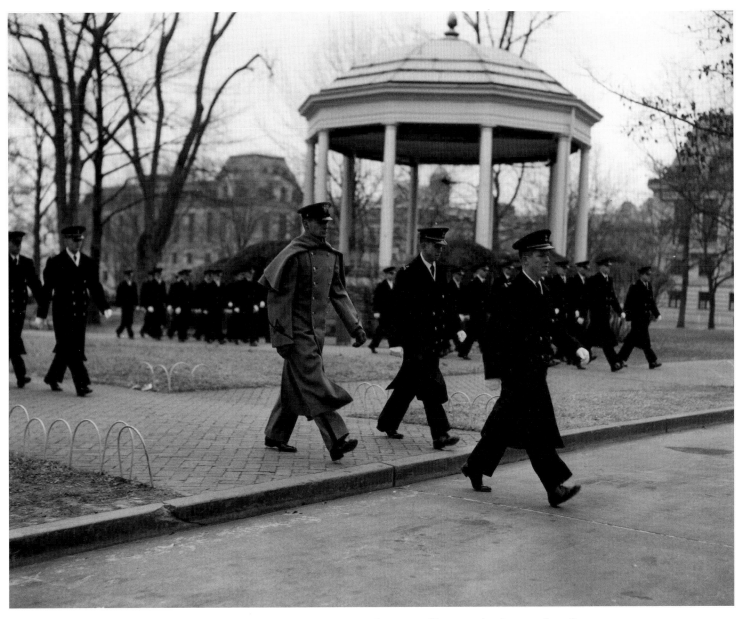

In more recent years, exchanges have extended to the Superintendents and senior staff personnel, who attend conferences, which rotate each year among the service academies, to exchange experiences and successful solutions to common problems. This is another image of Exchange Weekend 1955.

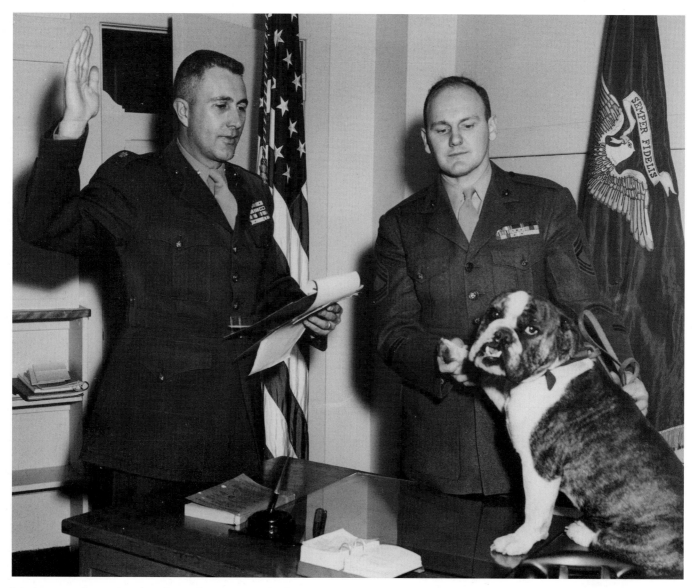

Marines were first assigned to the academy in 1866 "to lend their martial presence to ceremonial occasions."
Midshipmen could select service in the Marine Corps beginning with the class of 1881. The first Marine officer
instructors joined the faculty in 1932 and their successors have taught ever since. Here Lieutenant Colonel Paul Jones,
commanding Marine Barracks, Annapolis, swears in the local mascot "Nipper." English bulldogs have been the mascot
of the Corps since World War I.

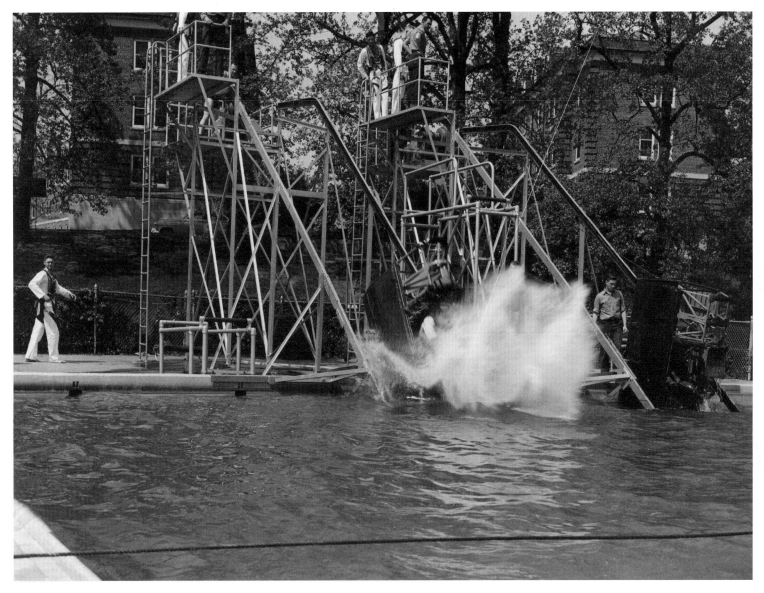

Even the Naval Academy recreational outdoor swimming pool has served as a laboratory. Here the proper procedure for escaping an aircraft downed in the water is being studied. The multi-phase ditching trainer was called a Dilbert Dunker, after the World War II–era cartoon character Dilbert, a screw-up Navy pilot. Similar devices were used at naval aviation bases until recently, as part of aviation survival training.

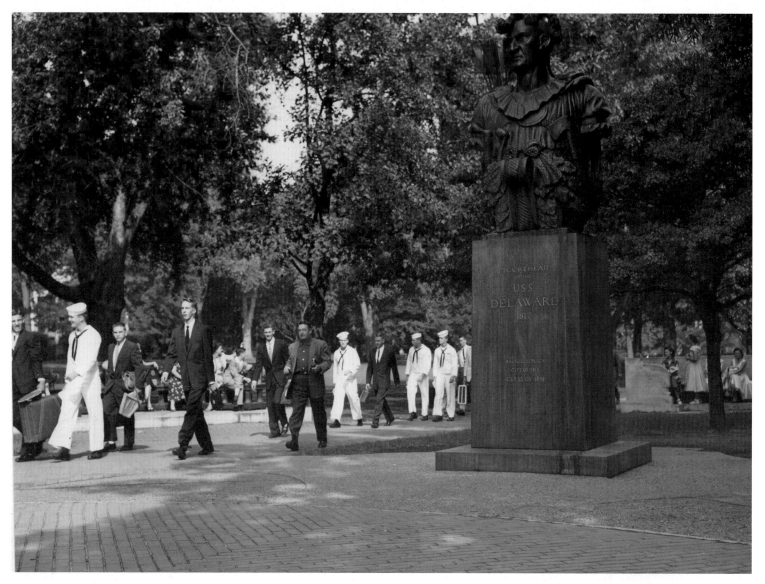

On June 27, 1955, members of the future class of 1959 are seen arriving in the yard. Some of these plebes are in civilian clothes, fresh out of high schools, and some are in sailor's uniform, identifying them as those appointed to the academy from the active fleet.

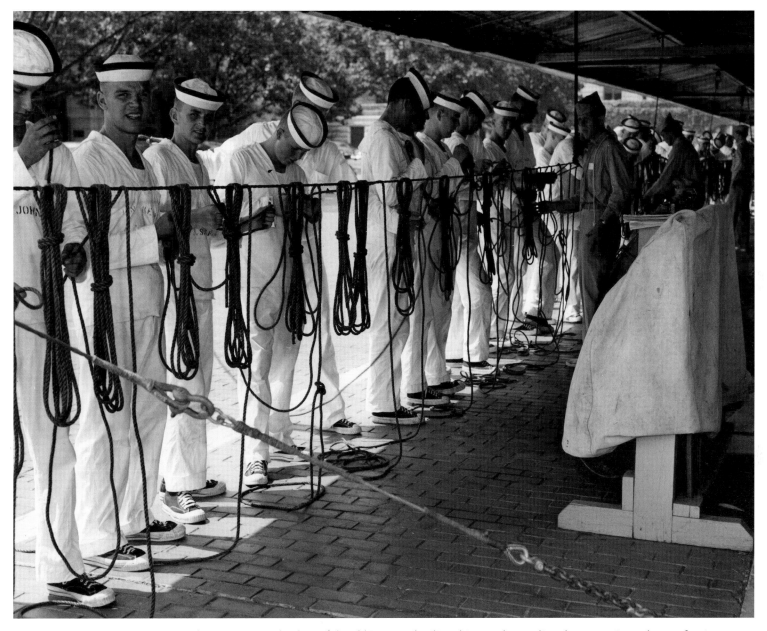

Learning the ropes. From the days of the old Navy and sailing ships, understanding the properties and uses of various ropes was most important. These plebes are being taught at the boat shed by recent graduates about the rope lines used on the academy's sailing craft.

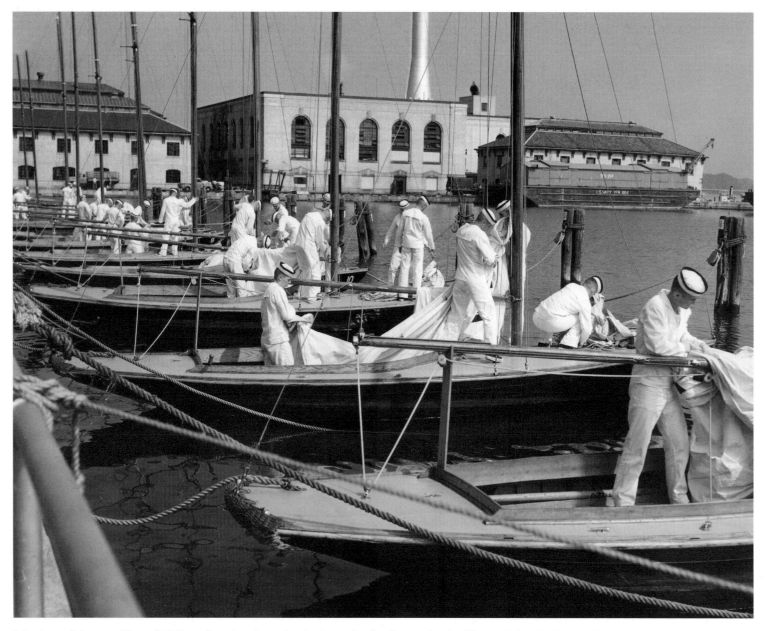

Members of the new Class of 1959 are learning about the rigging and sails of recreational sailboats tied up in Dewey Basin. The old, coal-fueled power plant designed by Ernest Flagg stands in the background.

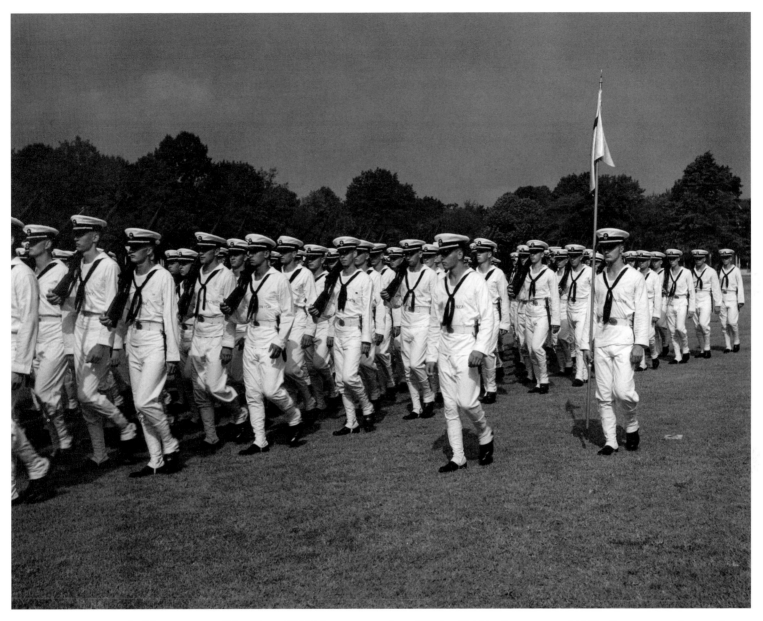

A plebe company of the Class of 1959 learns to march on Worden Field in the summer of 1955. Summer practice parades are usually held in the evenings to avoid the hot and humid conditions of Annapolis in July and August.

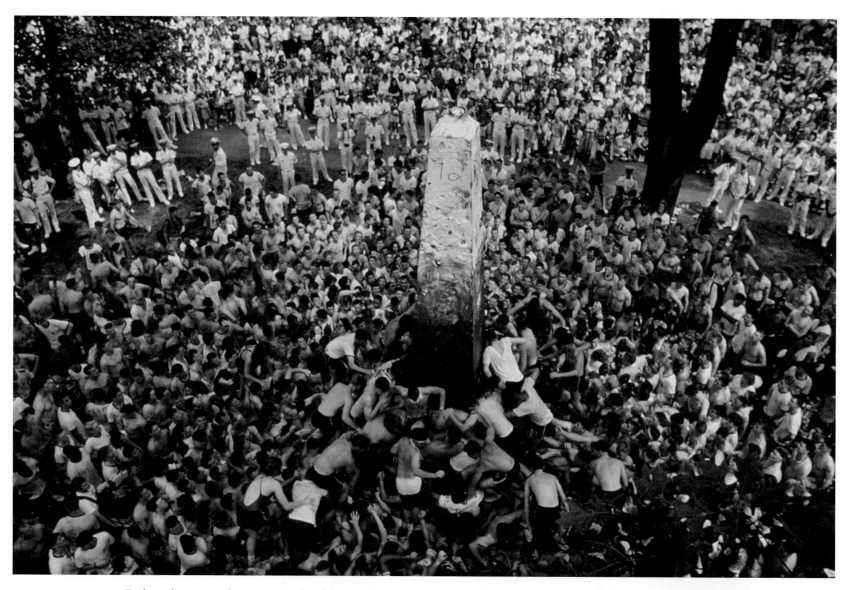

Each graduation week since 1940, the plebe class has climbed the Herndon Monument to place a hat on top to prove that they have conquered their plebe or freshman year, considered the most difficult. Beginning in 1949, the upperclassmen made the task more difficult by coating the monument with grease. Thousands of spectators come to observe the ritual, which can last from one minute, thirty seconds in 1969 (forgot to grease it) to four hours, five minutes, and seventeen seconds in 1995.

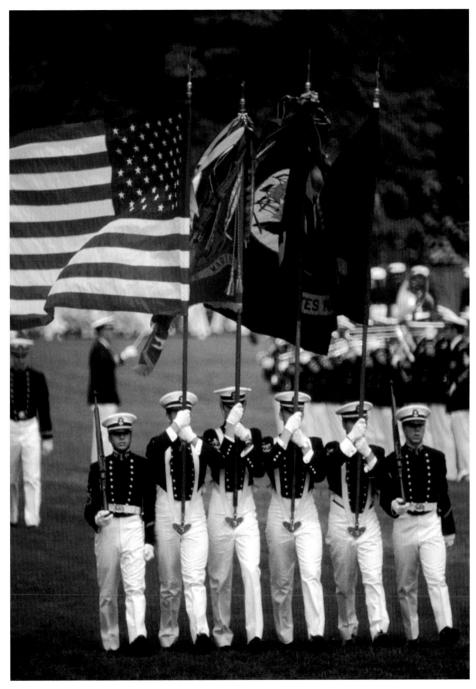

The color guard in parades each year are members of the color company selected at the end of second semester as the unit with the best overall academic grades, best athletic prowess, and best ability to march. For many years only two flags were carried in parades, the national ensign or flag and the Navy infantry battalion flag, a blue field with centered white diamond and upright blue fouled anchor. In recent years four flags are carried, the national colors, Marine Corps flag, Department of Navy flag, and the U.S. Naval Academy flag.

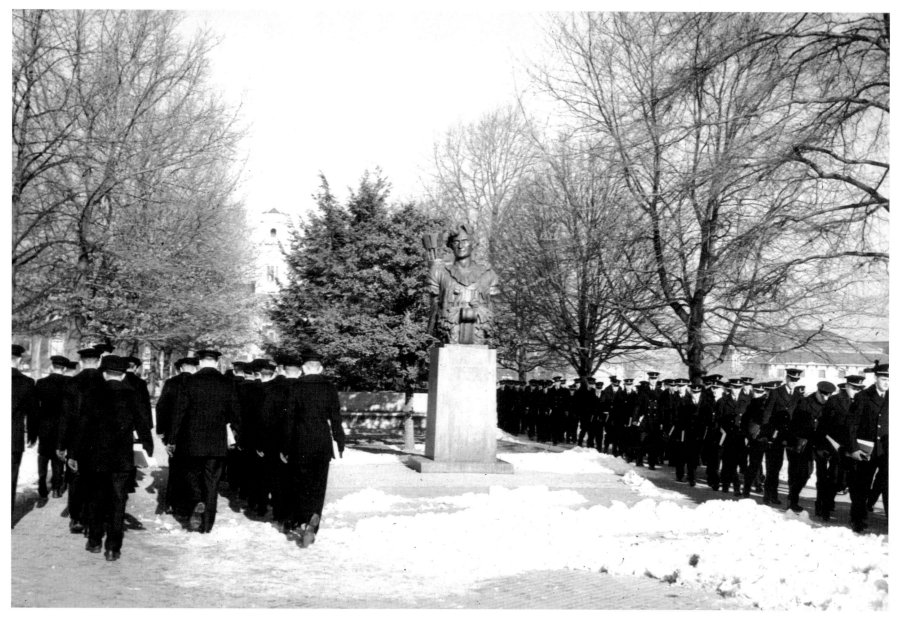

Until 1959 midshipmen marched to class in formation because everybody took the same courses. With the introduction of elective courses and of the majors program, it was no longer efficient to march in units to class.

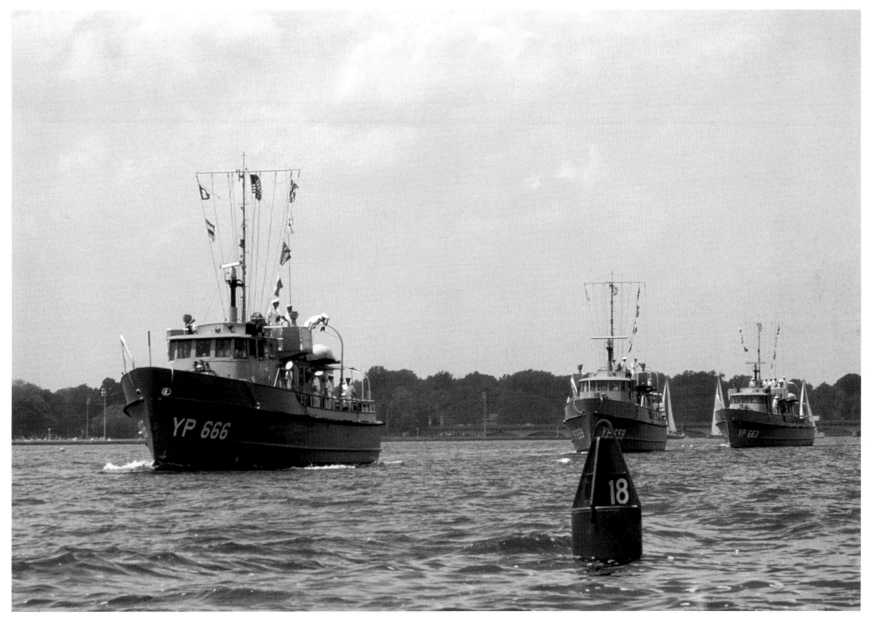

Since 1939, yard patrol craft (also known as YPs), maintained by Naval Station, Annapolis, have been used to train midshipmen in navigation, ship handling, fleet tactical maneuvering, rules of the road, shipboard military procedure, and to gain an appreciation of being at sea. The YPs have been updated with newer, improved classes of the boat several times over the years.

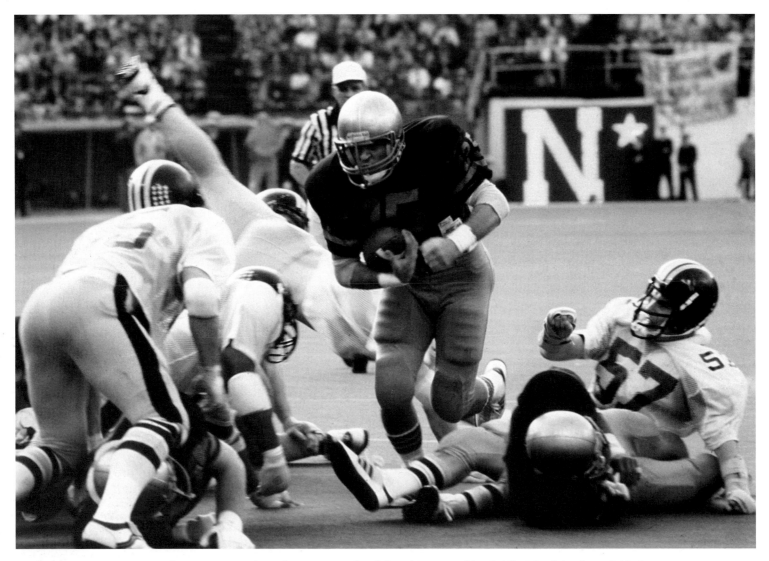

Navy participates in 31 intercollegiate sports and in other sports on the club and intramural levels. The Naval Academy Athletic Association, a private, nonprofit established in 1890, runs the intercollegiate program. Football is the sport that captures the most public attention, and in particular the Army-Navy game, which was first played in 1890. Navy also enjoys an enviable record of playing in many different post-season games—the Rose Bowl (1923), Sugar Bowl (1954), Orange Bowl (1960), Cotton Bowl (1957 and 1963), Holiday Bowl (1978), Garden State Bowl (1980), Liberty Bowl (1981), Aloha Bowl (1996), Houston Bowl (2003), Emerald Bowl (2004), Poinsettia Bowl (2005 and 2007), and Meineke Car Care Bowl (2006).

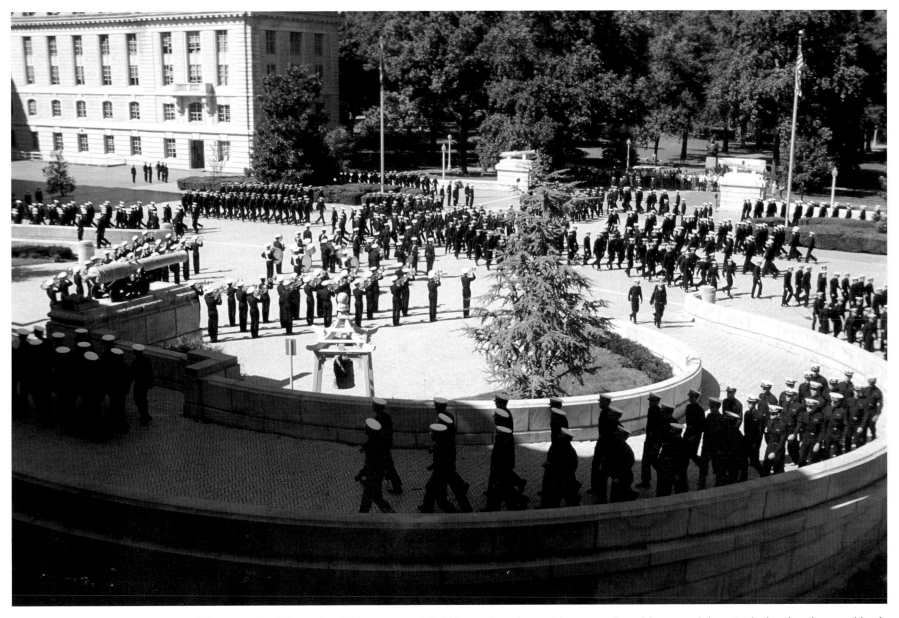

The Noon Meal Formation. This ceremony is held in good weather and is open to the public on weekdays. As the band or drum and bugle corps play "Anchors Aweigh" and the "Marine Corps Hymn," the midshipmen march up the ramps on their way to lunch in King Hall.

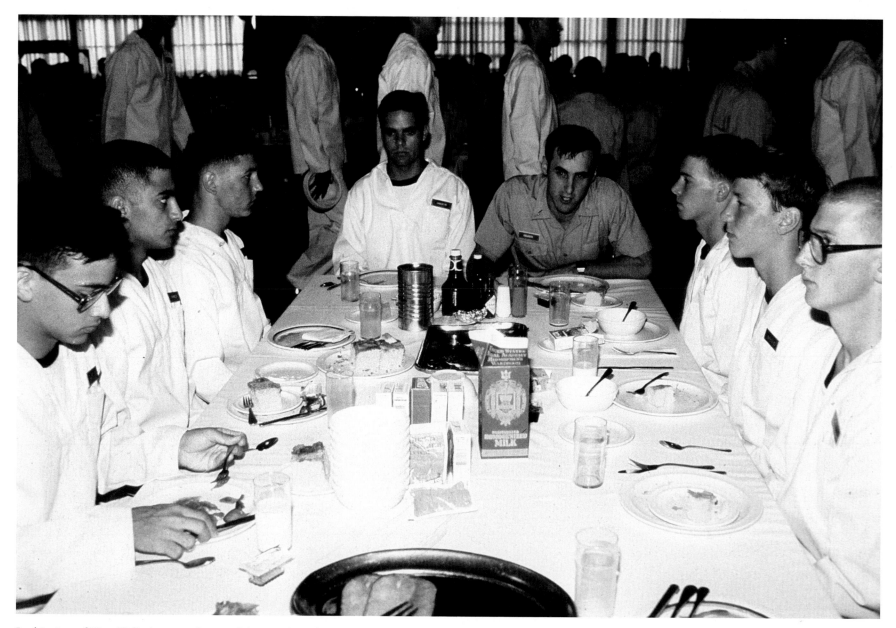

In this view of King Hall, the coat-of-arms of the Naval Academy is visible on the milk carton. It can also be found on the ketchup bottle and mustard and peanut butter jars. The mess uses so much of these items, manufacturers can afford to appropriately label them. The students are fed family-style and dine in about 40 minutes.

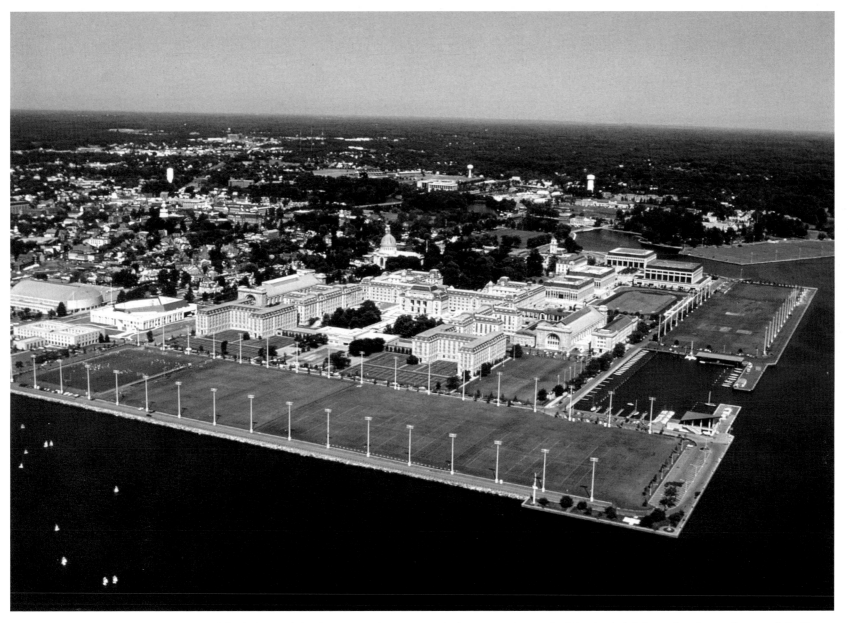

The U.S. Naval Academy occupies 338 acres in downtown Annapolis, Maryland. It is located at the confluence of the Severn River, Spa Creek, and the Chesapeake Bay.

Afterword

The U.S. Naval Academy has graduated more than 74,000 professional officers for service in the U.S. Navy and U.S. Marine Corps. Among its most illustrious graduates are Admiral of the Navy George Dewey, NA 1858, the victor at Manila Bay; Dr. Albert A. Michelson, NA 1873, the first American awarded a Nobel Prize in physics; Admiral William S. Sims, NA 1880, senior American naval officer in Europe in World War I; and the four fleet admirals of World War II—William D. Leahy, NA 1897, Ernest J. King, NA 1901, Chester W. Nimitz, NA 1905, and William F. Halsey, Jr., NA 1904. President Jimmy Carter graduated in the Class of 1947 and served in nuclear submarines before becoming governor of Georgia, president of the United States, and a Nobel peace prize laureate.

The academy is proud to boast that it has educated more astronauts than any other school. Some 53 astronauts have graduated from the Naval Academy, including Alan B. Shepard, NA 1945, the first American to fly in space, aboard the Mercury capsule *Friendship 7* on May 5, 1961. Most of the space shuttles in recent years have had at least one academy alumnus aboard and there have been flights with as many as three. Athletic heroes include Joseph M. Bellino, NA 1961, and Roger T. Staubach, NA 1965, who were awarded college football's Heisman Trophy. The latest Navy athlete to make the front of the Wheatie's cereal box is David Robinson, NA 1987, who actually appeared twice, once for his performance in the Olympics and once for his outstanding professional career in basketball.

The U.S. Naval Academy was designated a National Historic Landmark in 1963. It is open to the public for visiting, seven days a week from 9:00 A.M. until sunset. Driving aboard is restricted and entering on foot requires a photographic identification such as a driver's license. Additional security restrictions, without advance notice, can limit access from time to time. A Visitors Center, located inside Gate #1 at 52 King George Street, Annapolis, offers an orientation program, exhibits, guided tours of the yard, and a giftshop. For current information about tours call ahead to 410-293-8687.

NOTES ON THE PHOTOGRAPHS

These notes, listed by page number, attempt to include all aspects known of the photographs. Each of the photographs is identified by the page number, a title or description, photographer and collection, archive, and call or box number when applicable. Although every attempt was made to collect all data, in some cases complete data may have been unavailable due to the age and condition of some of the photographs and records.

BIBLIOGRAPHY

Annapolis: The United States Naval Academy Catalog. Washington: Government Printing Office, annual editions.

Bacon, Mardges. *Ernest Flagg: Beaux-Arts Architect and Urban Reformer.* New York: Architectural History Foundation, 1986.

Banning, Kendall. *Annapolis Today.* Annapolis: Naval Institute Press, 1957.

Benjamin, Park. *The United States Naval Academy.* New York: G. P. Putnam's Sons, 1900.

Edsall, Margaret Horton. *A Place Called the Yard: Guide to the United States Naval Academy.* 1978.

Foster, Linda, and Roger Miller. *United States Naval Academy.* Baltimore: MMII Image Publishing, and Roger Miller, 2001.

Gibson, Karen. *Brigade Seats! The Naval Academy Cookbook.* Annapolis: Naval Institute Press, 1993.

Kohlhagen, Gale G., and Ellen B. Heinbach. *USNA: The United States Naval Academy a Pictorial Celebration of 150 Years.* New York: Harry N. Abrams, 1995.

Lucky Bag (U.S. Naval Academy Yearbook). Annual editions, 1894 to present.

Marshall, Edward C. *History of the Naval Academy.* New York: D. Van Nostrand, 1862.

Morison, Samuel E. *John Paul Jones: A Sailor's Biography.* Boston: Little, Brown & Co., 1959 (reprts. available in paperback).

Reef Points: The Annual Handbook of the Brigade of Midshipmen. Annapolis: Naval Institute Press (early editions by YMCA), annually, 1905 to present.

Simmons, Clara Ann. *A Naval Institute Book for Young Readers: The Story of the U.S. Naval Academy.* Annapolis: Naval Institute Press, 1995.

Soley, James R. *Historical Sketch of the United States Naval Academy.* Washington: Government Printing Office, 1876.

Stewart, Robert. *The Brigade in Review: A Year at the U.S. Naval Academy.* Annapolis: Naval Institute Press, 1993.

Sweetman, Jack, and Thomas J. Cutler. *The U.S. Naval Academy: An Illustrated History.* Annapolis: Naval Institute Press, 1995.

Symonds, Craig L. *Confederate Admiral: The Life and Wars of Franklin Buchanan.* Annapolis: Naval Institute Press, 1999.

Todorich, Charles. *The Spirited Years: A History of the Antebellum Naval Academy.* Annapolis: Naval Institute Press, 1984.

Travis-Bildahl, Sandra. *A Day in the Life of a Midshipman.* Annapolis: Naval Institute Press, 1996.

Warren, Mame, and Marion E. Warren. *Everybody Works but John Paul Jones: A Portrait of the U.S. Naval Academy 1845-1915.* Annapolis: Naval Institute Press, 1981.